Introduction to
DRAWING

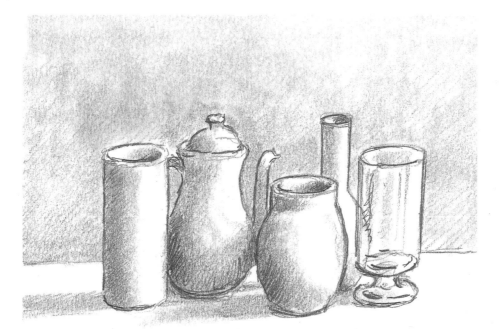

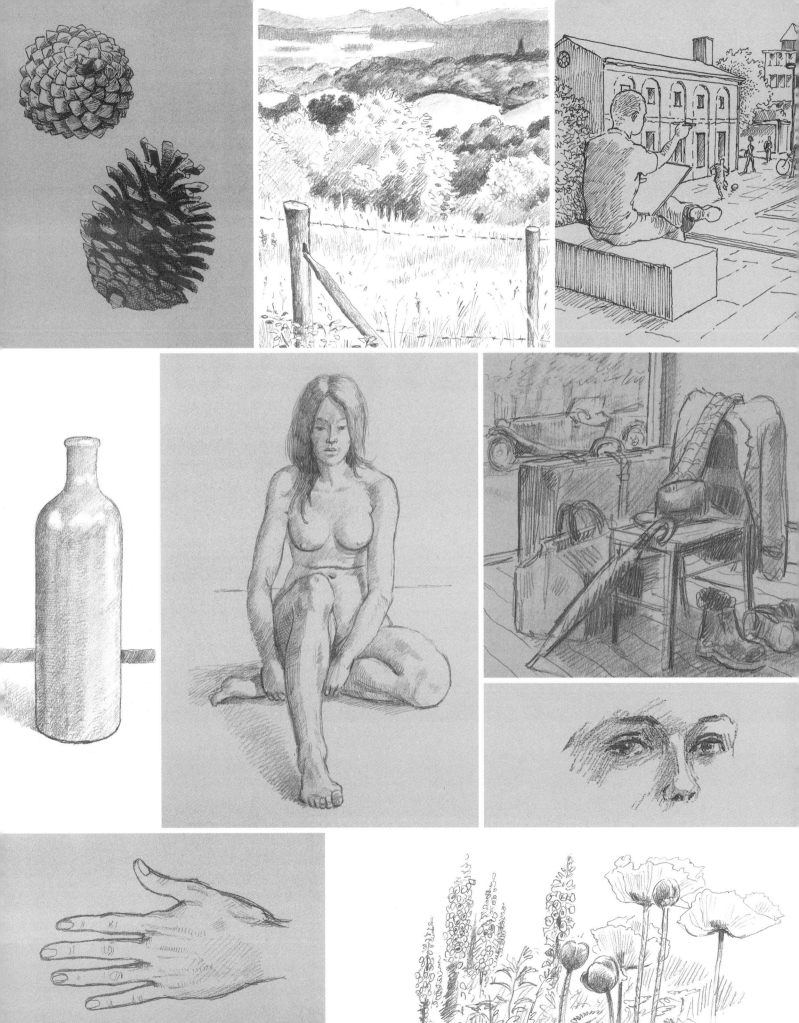

Introduction to
DRAWING

Practical easy steps to great artwork

BARRINGTON BARBER

ARCTURUS

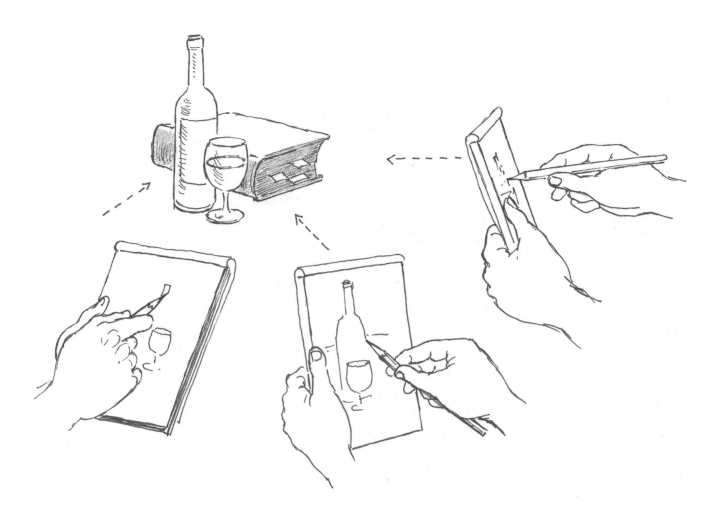

This edition published in 2015 by Arcturus Publishing Limited
26/27 Bickels Yard, 151–153 Bermondsey Street,
London SE1 3HA

Copyright © Arcturus Holdings Limited/Barrington Barber

ISBN: 978-1-78404-000-0
AD004285UK

Printed in China

CONTENTS

INTRODUCTION

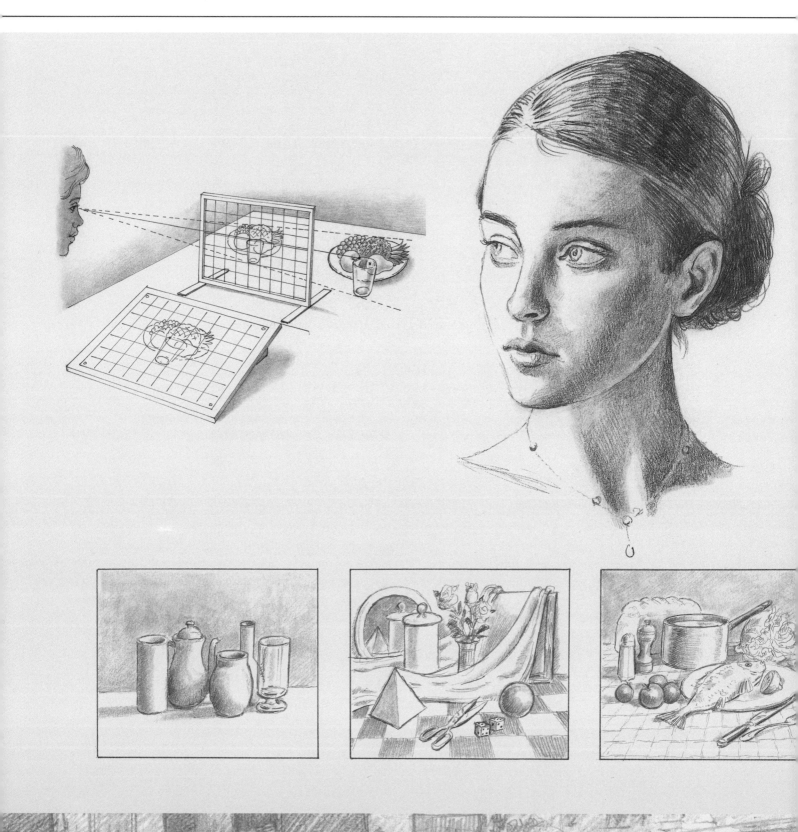

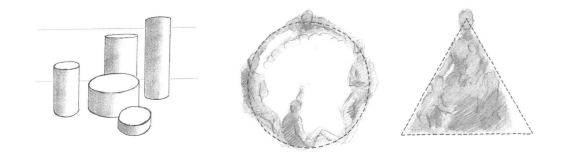

Starting to draw is an interesting and sometimes daunting business. I want to help you find ways of gradually improving your skill and thereby increasing your enthusiasm, because this is perfectly possible, no matter how little formal teaching you may have had. One of the great advantages of coming to drawing relatively unpractised is the freshness with which you can approach the subject. So even if you are a complete novice, this book should help you to get some drawing practice under your belt and produce some lively pictures.

The principal skill in drawing that you need to achieve is the co-ordination of the eye and the hand. It is not as difficult as it sounds, because we all learn to do this naturally by having to pick things up, catch a ball, write a list and the many other day-to-day tasks that we perform. The eye can see very much more than we generally give it credit for and our mind analyses the information quite readily and with remarkable accuracy. It is also amazing how precisely our hands can move, with just the right amount of pressure and degree of judgement, when required. When you are drawing, these skills will naturally come to your aid, as long as you don't get in the way of the action by thinking too much. In fact, thinking too much is often the chief obstacle to making improvements in drawing.

We shall look at the materials that you require if you are going to draw seriously and at ways of using them to their best advantage, so you don't waste time trying to find that out for yourself. Nevertheless, it's a good idea to do some experimentation when you try any new medium – you may discover a way of using it that you particularly enjoy.

You will find a series of exercises to help you refine your eye and hand co-ordination, which takes practice if you really want to draw well. Many of the exercises I demonstrate are time-honoured ones, used by artists for centuries. I shall also give you an understanding of basic elements of successful picture-making such as composition, creating a sense of depth and showing perspective. You will discover how to draw still life compositions and landscapes before progressing to the most difficult genre of all – the human figure and face. Eventually you will be able to build a complete picture of almost anything you care to imagine.

Skill isn't achieved overnight: you may sometimes feel you are taking two steps forward and one back, when a drawing you feel satisfied with is followed by one that just doesn't go well. However, I can guarantee that if you carry out all the exercises in this book, and practise regularly, there will be a remarkable improvement in your work. So, I wish you good luck and happy drawing.

BASIC MARK MAKING

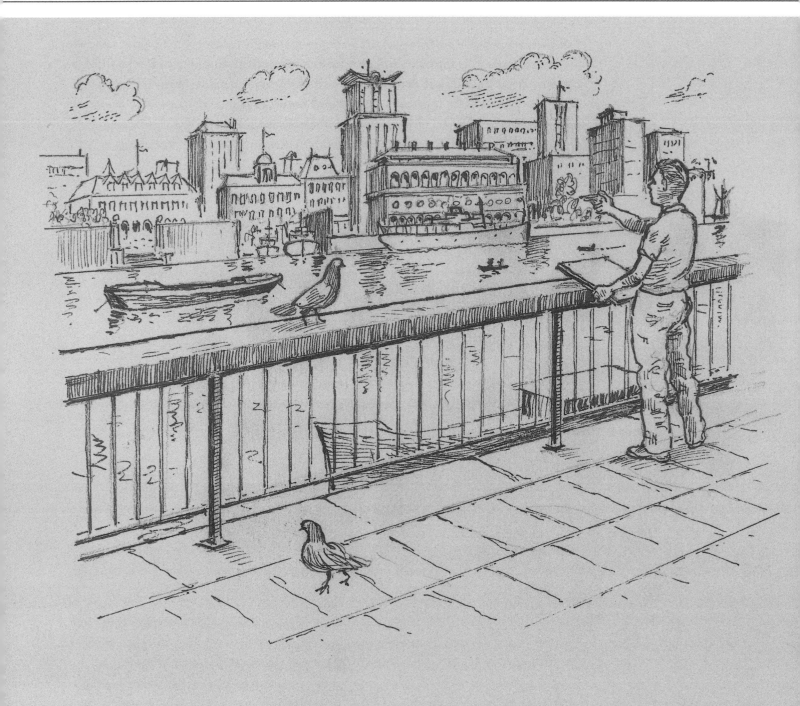

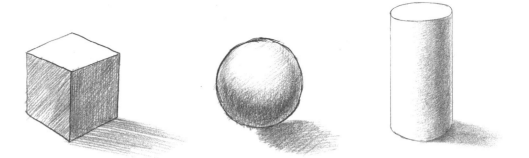

When you draw, you make marks on paper to represent a visual experience that viewers will recognize from their own knowledge of the world: the drawings are illusions of form and shapes that we all see. So effective mark-making is important to create a convincing illusion and you need to put in plenty of practice to improve your ability to do it easily and well.

Probably the first thing to consider when you begin to draw is exactly how you are going to organize yourself. So, in this section we shall examine whether you sit or stand to draw; the way you hold your drawing implements; how you assume your viewpoint; and even the size of the image that you draw. It is well worth spending time over these matters, although they are mostly a matter of common sense.

We shall also look at the materials and mediums that are commonly used for drawing, as well as accessories such as brushes, sharpeners and erasers. Then it's time for you to put pencil to paper and start on your path to becoming an artist by means of exercises as simple as making dots, lines and geometric shapes before going on to discover how to show tone to give your subjects the impression of three-dimensional form. You will be surprised by how much confidence you have gained once you have practised these early steps.

Positions and grips

Here we consider ways of standing or sitting to draw and how to hold the drawing tool to get the best results.

When you are drawing objects laid out upon a table, you can sit and work on a drawing board large enough to take the size of paper you are using. You can attach your paper with clips, drawing pins or masking tape. Of these, I prefer the last as the paper can be changed more easily and it doesn't matter if you lose the bits of masking tape.

To draw standing up, which is much the best way, you will need some kind of easel. This will be more expensive than any other piece of equipment you will have to buy, but easels last for ever if you are careful with them and make drawing so much easier. There are several types, such as portable easels, radial easels (my own favourite), and large studio easels, which you need buy only if you have sufficient space, prefer the design and are intent upon a career in art.

The way that you hold your drawing tool has a big influence on your drawing skill. Try to relax your hand and wrist and hold it loosely so that there is no unnecessary tension; the quality of your line should improve immediately.

Also try out different ways of holding it, for instance more like a stick or sword than a pen. The pen-holding method is not wrong but is often too constrained for really effective drawing.

Sketching

Going to a place that you know, and simply drawing what you see to the best of your ability, is one of the best exercises that you can perform. Rather than loose sheets of paper, consider keeping a bound sketch book to record your immediate impressions of a scene. You will need a small one (A5), and another one a bit larger (A4 or A3). There are many versions with various types of binding and you can just choose those that suit your particular needs.

When you make sketches of things, people and places, you will need to draw them from several viewpoints to become really familiar with them. Don't forget to include as many details as you can, because this information is often useful later on.

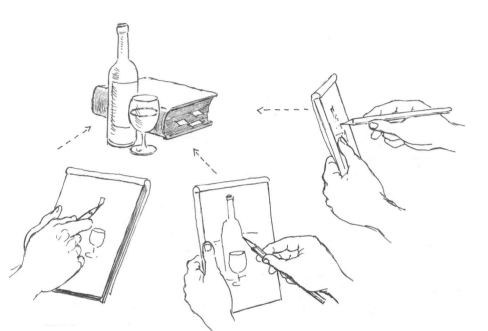

Measuring and framing

There are various ways of measuring the subjects of your drawings and this one is called 'sight size' drawing, where you reproduce everything the size that it appears to you from a fixed point of view. This system is very useful where you have a large area to draw, but it is often difficult to correct when you go wrong because the difference between the right and wrong marks on the paper can be very small.

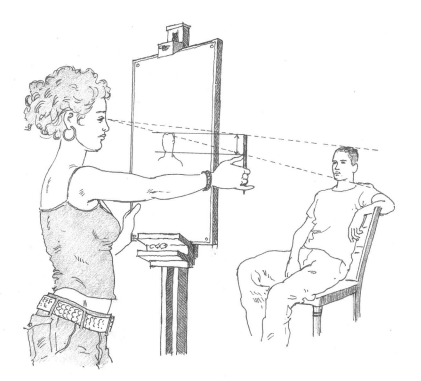

Position your subject at a distance where the drawing and the subject will appear to be the same size. Hold your pencil at arm's length to ensure it is always the same distance from you, use your thumb to indicate measurements and transfer these to your drawing. When you are portraying smaller subjects, take measurements to get the proportions right, but draw the item larger in order to make correction easier. It is important to correct your drawings rigorously in order to learn to draw well.

It is always a good idea to take photographs to supplement your sketches. The information you require to work further on your drawings cannot be too detailed. And don't forget to take the subject from more than one angle, exactly as you would if you were sketching it.

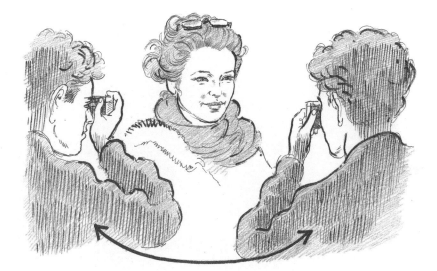

Another thing that you should consider before deciding on your finished piece is whether your composition is to be a vertical ('portrait') or horizontal ('landscape') picture. Make sure you try out both possibilities before you get too involved.

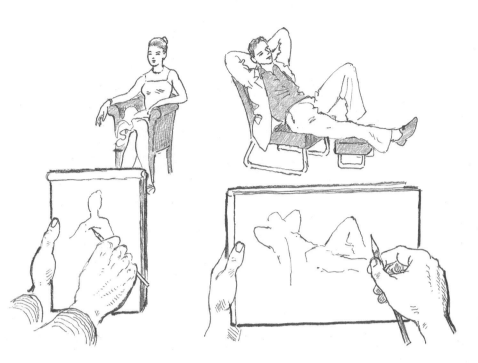

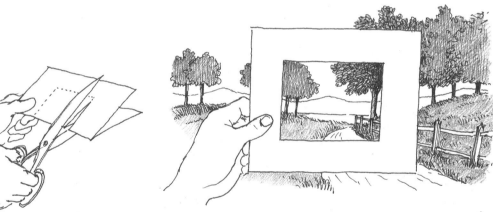

A framing device is very useful in helping you to compose your picture. From any small sheet of paper or card, cut out a rectangle that seems roughly the same proportion as your working surface to make yourself a viewfinder. Holding this up to your eye and viewing the subject matter through it allows you to try several ways of composing your picture, deciding what you want to include and exclude. It eliminates all the immediate surroundings so that you can concentrate on seeing exactly what will appear in your composition.

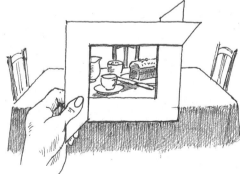

A more adaptable version of the cut-out rectangle is a pair of right-angled strips (L-shaped) that you can arrange to any proportion that suits you.

Materials and mediums 1

The next thing to consider before you start drawing is the choice of materials and mediums that you could use. There are many possibilities and good specialist art shops will be able to supply you with all sorts of materials and advice. However, here are some of the basics that you will probably enjoy trying out.

Pencils, graphite and charcoal

Good pencils are an absolute necessity, and you will need several grades of blackness, or softness. You will find a B (soft) pencil to be your basic drawing instrument, and I suggest a 2B, 4B, and a 6B for all your normal drawing requirements. A propelling or clutch pencil will be useful for any fine drawing that you do, because the lead maintains a consistently thin line. A 0.5mm or 0.3mm lead is a good choice.

Another useful tool is a graphite stick, which is a thick length of graphite that can be sharpened to a point. The edge of the point can also be used for making thicker, more textured marks.

Charcoal, which is basically a length of carbonized willow twig, is of course a historic drawing medium. This will give you a marvellous smoky texture, as well as dark heavy lines and thin grey ones. It is also very easy to smudge, which will help you to produce areas of tone quickly.

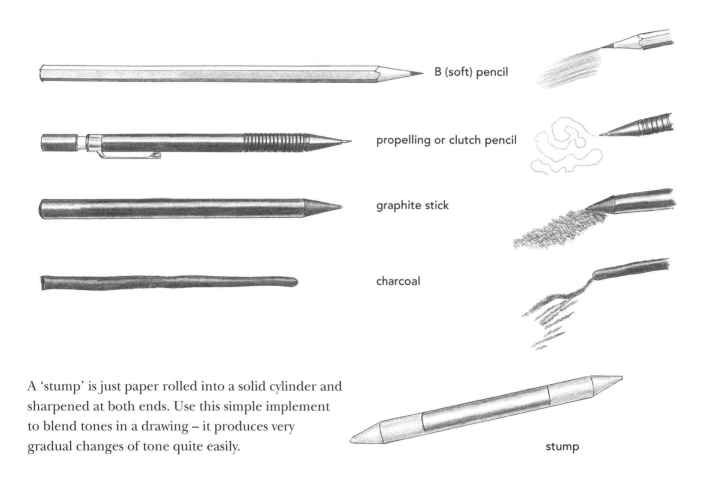

B (soft) pencil

propelling or clutch pencil

graphite stick

charcoal

A 'stump' is just paper rolled into a solid cylinder and sharpened at both ends. Use this simple implement to blend tones in a drawing – it produces very gradual changes of tone quite easily.

stump

Scraperboard

Scraperboard is a very distinctive method of producing a drawing. You work on special card coated with a layer of china clay that has either a white surface or a black one. The white surface is for the use of added colour, and the black surface for incised line drawing. With an instrument rather like a stylus, you scratch lines and marks on the black surface to give a white image on a black background. The effect is attractive and very similar to a wood engraving or woodcut. At one time scraperboard was widely used in commercial illustration.

scraperboard tool

Pen and ink

There are various pens available for ink drawing, a satisfying medium for many artists. The ordinary dip pen can produce lines of either great delicacy or boldness just by variation of pressure on the nib. With this you will need a bottle of Indian ink, perhaps waterproof, or a bottle of liquid watercolour.

liquid concentrated
watercolour

Indian ink

dip pen

graphic pen

A modern graphic pen that uses interchangeable nibs in a range of thicknesses is more like a fountain pen, with its ink stored in a cartridge. It produces a consistent fine line.

Materials and mediums 2

Felt tip pens and markers

Further choices for the artist are felt tip pens, which are thicker than the graphic pens, and permanent markers, which produce very thick lines in indelible colours.

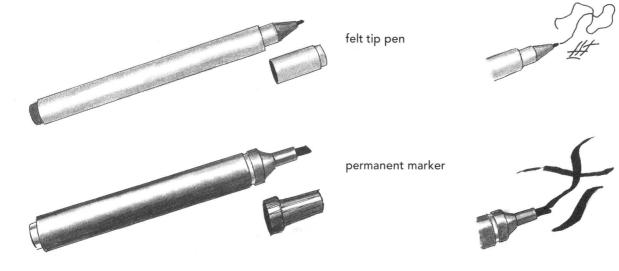

felt tip pen

permanent marker

Brushes

You will also need a couple of brushes so that you can put on larger areas of tone when you need to; Nos 2 and 8 are the most useful. The best brushes are sable hair, but some nylon brushes are quite adequate.

No. 2 sable or nylon brush

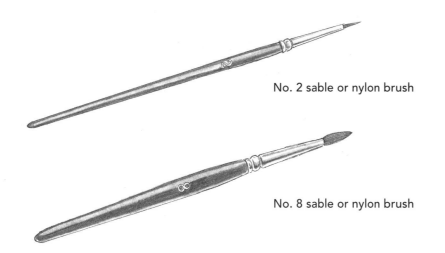

No. 8 sable or nylon brush

Erasers and sharpeners

When drawing in pencil you will almost certainly want to delete some of the lines you have drawn. There are many types of eraser, but a good solid one (of rubber or plastic) and a kneadable eraser (known as a 'putty rubber') are both worth having. The putty rubber is a very efficient tool, useful for very black drawings; used with a dabbing motion, it lifts and removes marks leaving no residue on the paper.

putty or kneadable eraser

soft rubber eraser

scalpel

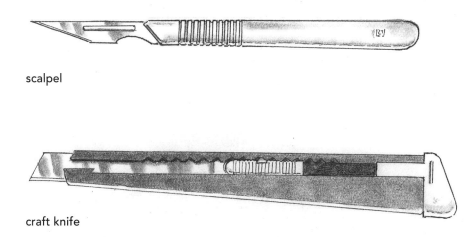

craft knife

You will need some way of sharpening your pencils frequently, so acquiring a good pencil-sharpener, either manual or electric, is a must. Many artists prefer keeping their pencils sharp with a craft knife or a scalpel. Of the two, a craft knife is safer, although a scalpel is sharper. Scalpels can be used as scraperboard tools as well.

Practice exercises in basic drawing

Learning how your drawing tools respond when you make marks with them is essential. These exercises will both develop your hand-eye co-ordination and familiarize you with the marks that are possible.

Start with what must be the easiest thing of all to draw . . . a dot. Having put pencil to paper, you can carry on adding more dots, clustering them together carefully until you have produced a circular shape in which all the dots seem to be the same distance apart.

Next, try something a little more structured: having achieved a shape of some kind on the paper, visualize a square and, by lining up the dots carefully, produce one made up entirely of equally spaced dots. This requires the engagement of the intellect with the activity and is one of the first lessons for an artist: that everything you produce is an illusion based on the brain's ability to order and re-form the universe about you. Nothing of course has really changed, apart from your own view of how you see the world, but that is what an artist does. He or she interprets and represents experience in order that others may also have a new experience.

Now there follows a whole series of simple marks to help you devote all your attention to that place where the pencil meets the surface of the paper.

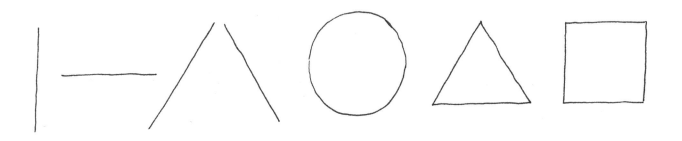

First draw a vertical line, then a horizontal line, then a diagonal, and then another diagonal in the opposite direction. Next, draw a circle without recourse to a compass, then an equilateral triangle, followed by a square, and then – more difficult – a five-pointed star. Lastly in this series, try a spiral, either from the centre out or from the outer edge coiling inwards. You have begun to draw!

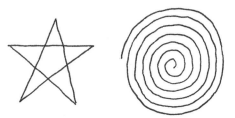

The next stage is also quite simple but requires your sustained attention, which is excellent training for an artist.

Visualizing a square, draw vertical lines all the same distance apart and as straight as you can make them. While doing this, concentrate your attention on the point of the pencil as it travels across the paper. This will focus your mind on the task in hand and bring an artistic touch to the way that you draw even the simplest of marks.

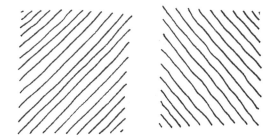

Go on to do the same thing with horizontal lines. Next, to make things slightly harder, try diagonals one way, and then the other.

Now, combining your verticals and horizontals, produce a chequered square.

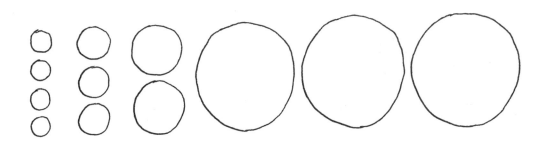

Let us go for something freer but more difficult to get right, and that is a series of small circles. After these, make some more circles, twice as big. Then double the size again. Next, double up on that size and repeat the circles until they start to look a bit more evenly circular. Don't rush this stage. Go as slowly as you like, then when you find yourself getting quite good at it, speed up a little while still endeavouring to keep the circles absolutely circular.

Tonal exercises 1

Here are several ways to create tone that looks subtle and convincing. The purpose of this is to emulate the effect of shadow on a surface that may be either curved or flat.

Starting with a well-sharpened pencil, draw a series of closely packed straight lines in a diagonal pattern. It doesn't matter which diagonal you choose because you will be doing the opposite diagonal later.

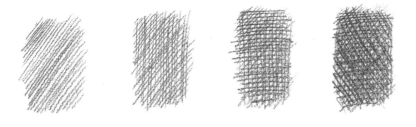

Do the same with vertical lines over the top of the diagonals. Notice how this increases the depth of the tone. Next, proceed similarly with horizontal lines. Finish with a series of diagonals across the previous diagonals. You have now increased the depth of tone fourfold.

Now build up a tone by placing small groups of short lines closely together, so that there is hardly any space between them. Make sure that they go in all directions, as shown.

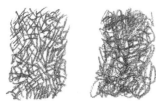

Do the same with random short marks which cross over each other to create a tonal area. Next, build a tone from one single line without lifting the pencil off the paper, crossing it backwards and forwards in all directions.

Now have a go at smudging one of your earlier attempts at shading by rubbing it with your finger or a paper stump.

Make a fresh tonal area using the edge of the pencil lead or, even more effective, the edge of a graphite stick. This renders a wide smudgy mark quite easily.

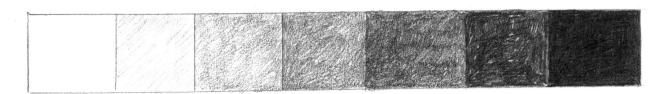

Next, try a rather more disciplined exercise in shading skill by constructing a 'grey scale'. This time you will have to be aware of how much pressure you are putting on the pencil as you do your shading.

Draw a row of squares, not too large. Leave the first one completely blank, so you start with plain white. The second square should now be shaded with a tone as light as possible. This might take several attempts, as it's easy to overdo it. Then, in square three, shade a little more heavily. As you proceed along the row, make your

shading progressively heavier until you produce a completely black square in the last one. Go for a scale of seven or eight squares until you become really skilful, when you may be able to make nine or ten. See how far you can take it, but each square must be slightly darker than the previous one. You will gain increasing confidence and this will inspire you to emulate what Leonardo da Vinci and Michelangelo were able to do in their drawings to achieve the effect of light falling on a three-dimensional surface.

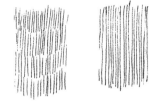

After these exercises, switch mediums and have a go using pen and ink. With a very fine-line pen, do a series of vertical strokes, quite short but all close together, to make an area of tone as shown. Next, do the same thing again with longer strokes that cover the whole depth of the area.

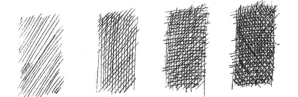

Now, as you did with the tonal exercises in pencil, draw diagonals with verticals over the top, and then horizontals over those two, followed by more diagonals in the opposite direction. You will see how the illusion of shadow or tone is produced by these exercises.

After that, try dots, and then a wriggling continual line that constantly crosses over itself rather like tangled thread.

Finally, pick up a brush and put on a quick wash of tone with diluted ink or watercolour in one brushstroke.

Tonal exercises 2

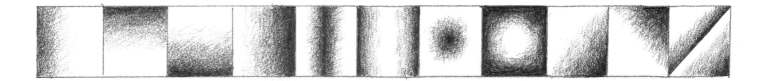

The shading exercise that possibly requires the most control here is this series of fading tonal squares, executed in pencil. There are eleven, and they produce varying effects of curved surfaces. Take your time over them; they are quite subtle.

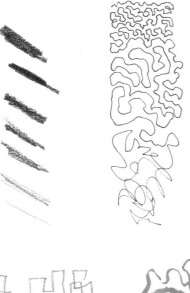

Test yourself in other mediums, such as a series of marks made with the graphite stick, or toning made with a fine-line pen in one long, uninterrupted line.

Try an angular version of the previous exercise with a pencil, and then with a loaded brush and diluted ink or watercolour.

Try a pencil line in a swirling, spiralling shape that crosses over itself continually rather like a cloud of smoke.

Then try a line that swings alternately from top to bottom producing a graphic set of curls, as shown.

Next comes a more angular line, which gently scribbles its way backwards and forwards over itself.

Now, take the same three sets of texture, and produce them in pen and ink . . .

. . . and then using a brush and diluted ink or watercolour.

These exercises are all designed to encourage your hand and eye co-ordination and to give you practice in controlling your marks with your drawing tools.

The illusion of three dimensions

The next stage is for you to move further into the realms of illusion and produce shapes that appear to exist in three-dimensional space.

Draw a neat square. Then, at three of the corners, add three short lines all the same length, leading diagonally away from it. Join the free ends of the lines with lines parallel to the sides of the square. Eureka! A cube, or what appears to be a three-dimensional shape, on flat paper. The more carefully you draw it, the more convincing it will be.

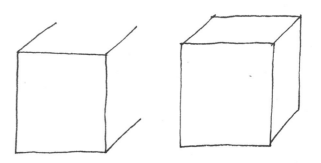

Now try another version. This time, draw a diamond-shaped parallelogram. Draw three vertical lines downwards from the three lower corners, all the same length. Join the free ends of those lines with lines parallel to the lower two sides of the diamond. Once more, you will observe that you have created the illusion of a three-dimensional shape. This may seem very simple, but it has a lot to do with learning to draw; you started by producing shapes that you first conceived mentally and have now made them evident physically. These shapes are worth practising as much as you feel will be useful.

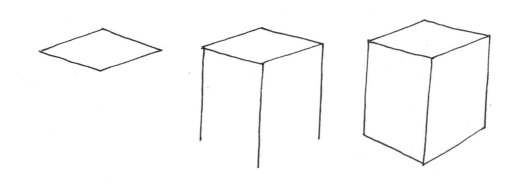

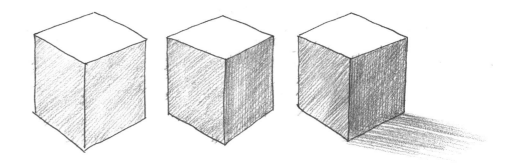

Having learnt to make a cuboid shape, lend it more verisimilitude by shading the two lower sides with an even, light tone. Next, select one of the shaded sides and shade it to an even deeper tone. Then finally, add an area of tone outside the shape of the cube to indicate a cast shadow. The illusion is now complete.

Now let's move on to circular shapes – globes, or spheres.

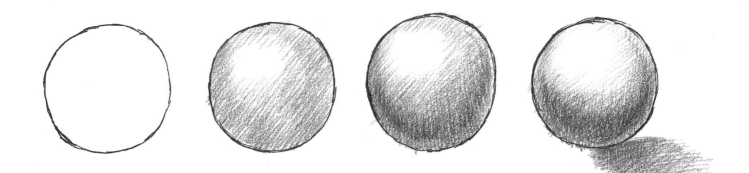

Start by drawing a circle as accurately as you can; the better the circle, the more effective the illusion. Then, with a very light set of pencil strokes, shade in an area of the circle leaving a small patch of unshaded space towards the upper left side, as shown. Having applied the first layer of shading, start another layer, rather smaller in area but deeper in tone, in a crescent around the lower right side of the circle. As you can see, it is beginning to look three-dimensional already. To add to the illusion, create a tonal area outside the circle to indicate a soft shadow, which the supposed sphere is casting on the supporting surface. All this helps to make your globe shape more convincing.

Ellipses and cylinders

Before starting on the last of these key three-dimensional shapes – a cylinder –
we need to look at the way to construct an ellipse. This is the shape that a
circle appears to make when it is seen from an oblique angle.

In the example, I show how a car tyre would appear as
you move your viewpoint over and above it, so that you
can see more of its circular qualities. Alongside is the
elliptical shape that the top of the tyre makes when seen
from an oblique angle. As you move from what appears
to be a straight line, the shape begins to widen across its
vertical axis, revealing the typical ellipse shape.

One of the properties of an ellipse is that each
quarter is exactly the same as the others, only in reverse
or mirror image (one quarter is shaded to indicate this).
There is no foolproof way of drawing an ellipse, except
to copy one and try to draw it as accurately as you can,
time and time again. It does take a bit of practice but as
you improve, you will find yourself able to create the
illusion of depth more convincingly.

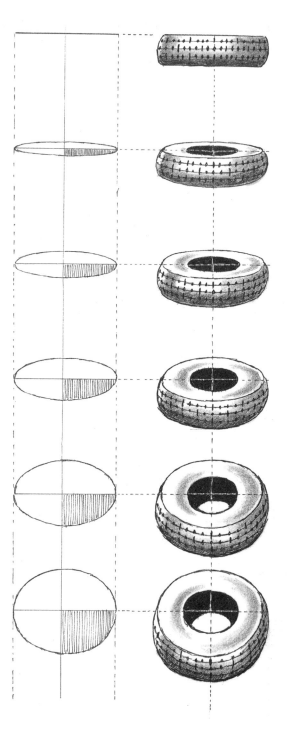

In order to draw a cylinder, first draw an ellipse as shown. Then project two vertical lines downwards from the narrow ends of the ellipse, keeping them parallel and the same length. Then at the lower end of the lines construct another ellipse, but this time you only need to draw the curved lower side.

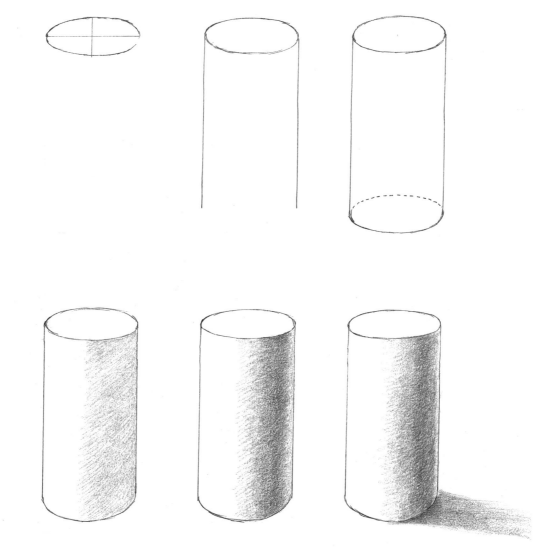

Having established the outline of the shape, shade the entire length of the cylinder on one side only, but not quite up to the edge. When you have one layer of tone on, making sure that it fades off towards the edges, put another narrower band of tone over the top in the middle of the previous tonal area, but slightly closer to the outside edge. Now, to complete the illusion, shade in an area projecting onto the surface that the cylinder is supposedly standing on, fading it out as it stretches away from the cylinder's edge. You now have the image of a free-standing cylinder.

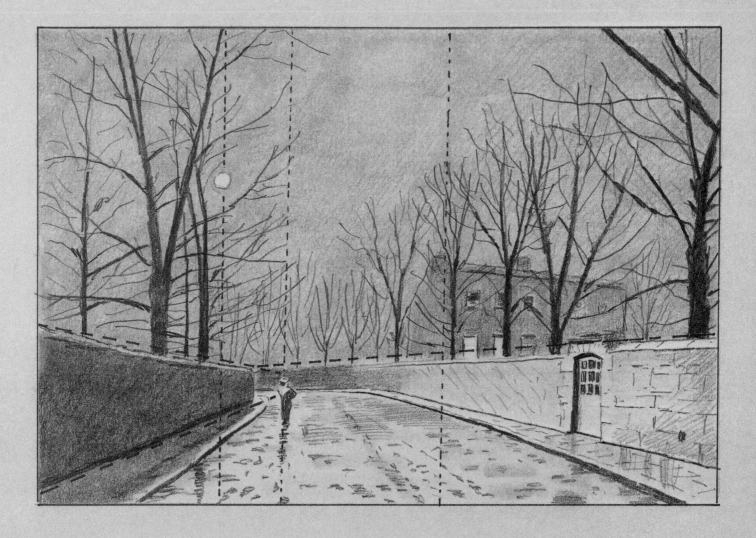

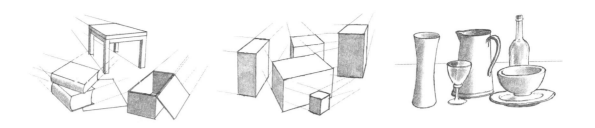

When an artist composes a picture, the objects within it are arranged in some way to make a strong design that will interest the viewer. This could be left to chance and the picture would then stand or fall by the instinctive understanding that the artist has for making a picture work. Generally, though, the artist decides in advance how the various parts of the picture are going to relate to one another, and carefully arranges the main shapes of the composition in a way that he or she thinks is appropriate.

One of the most common ways of doing this is to use geometric relationships within the picture frame. So, simply dividing the area of the picture into thirds, fifths and sevenths might be a start. Then, to relate one shape to another, you might line them up in a triangular formation or a curve which serves to take the eye across and around different parts of the composition.

This use of geometry can solve your compositional problems and give a harmonious proportion and balance to the picture. It is a very old method that painters have used for centuries to construct their pictures and make them more powerful. The eye naturally wants to find relationships between objects and will impose some sort of pattern on any random collection of shapes. In the following section, I shall be showing some of the ways that artists have done this in the past and suggesting ways that you might apply this to your own work.

Another aspect of making successful drawings, especially in the area of landscapes both rural and urban, is showing perspective – the apparent distortion of shapes as they recede from the viewer. In this section of the book you will also find the rules of perspective explained so that you know how to apply them in your pictures.

Geometric beginnings

When you employ geometry to construct your picture, it is best to start with very simple devices. Here are two basic geometrical figures that could be used for composing a picture.

The triangle has been used time and time again to produce extremely stable and powerful compositions, and when you go around a traditional art gallery it is interesting to note how many of the artists have used a triangular or pyramidal framework for their pictures.For example, it provides a very satisfactory basis for a group of figures.

The circle is used less often but is worth considering for creating a feeling of movement around the picture, without portraying the figures themselves in motion.

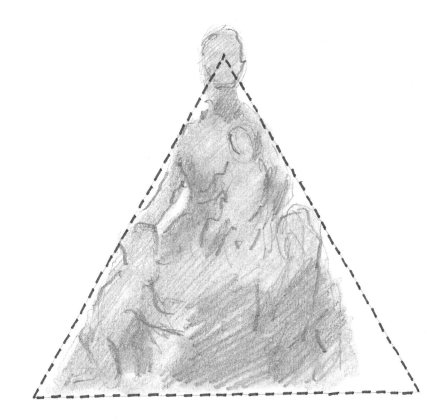

The two diagrams featuring rather softly
drawn figures give you some idea how
this might be achieved.

Dividing the picture

A trial approach to the composition of your picture is to divide the area with verticals and horizontals. The first obvious division is to cut it in half both ways so that you have a horizontal centre and a vertical centre. But this rarely provides a good enough balance, so the next thing is to try splitting the picture area into different proportions, such as thirds, fifths, or sevenths. These divisions, not being based on central lines, are more satisfactory.

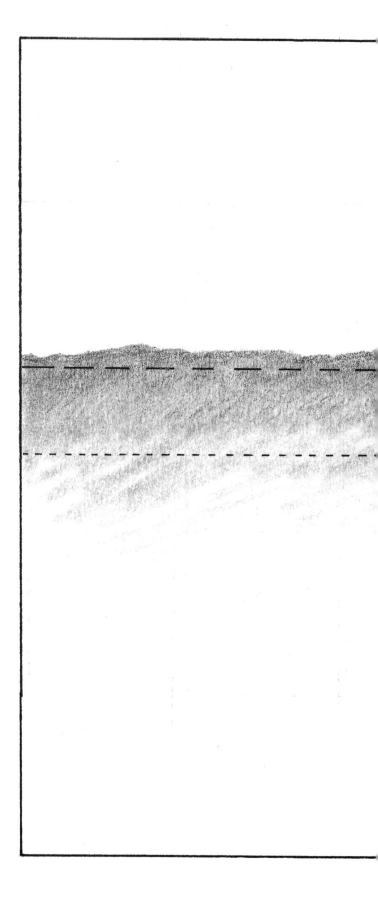

In the diagram, I have divided the picture plane into areas which are fifths horizontally and sevenths vertically. I have positioned the horizon line of distant hills at three-fifths from the base edge and two-fifths from the top.

The large tree feature divides the picture vertically at two-sevenths from the right-hand edge and five-sevenths from the left-hand one. This creates an interesting space each side of the main tree feature and places the horizon at a point where both the sky and the landscape have a strong role to play.

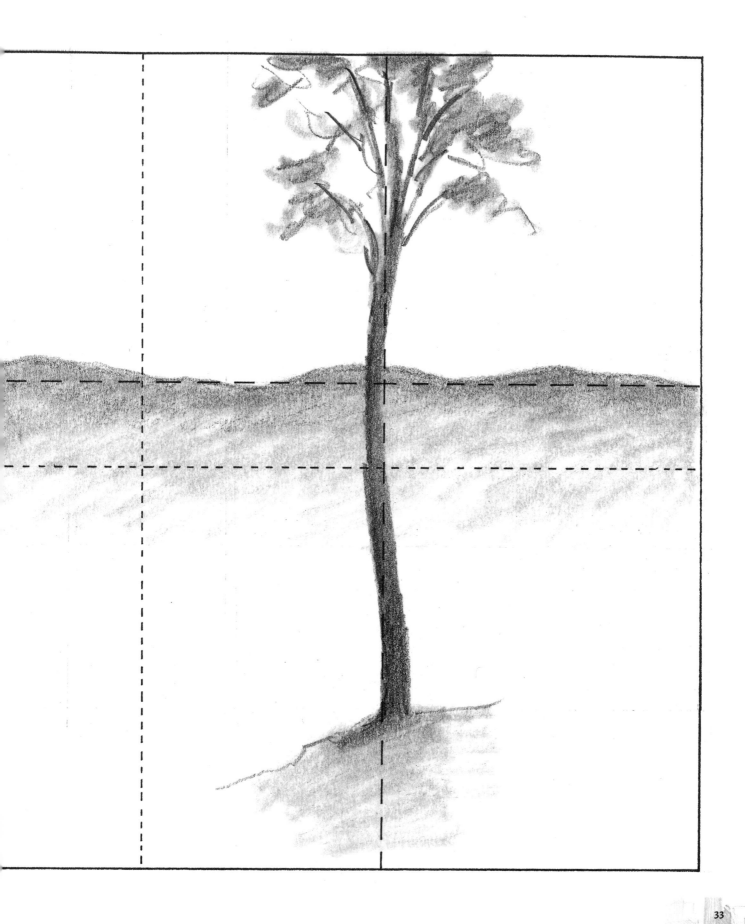

Manet's methods

These two examples of the work of Edouard Manet (1832–83) give us some idea of how he planned his canvases. Of course, they shouldn't be regarded as representing the way that he always worked out his paintings. Nevertheless, in these two instances, his mastery of composition was clearly both dramatic and successful.

In the first example, *In the Garden* (1870), he has divided the picture area with a strong diagonal, on one side of which are seated the key figures of the man and woman, with the woman and her long skirt dominating the space. On the other side stands the baby carriage, with the baby's trailing white gown making a triangular shape that points towards the main diagonal. It may be significant that the heads of the adults are in the same (upper) half of the picture as that of the infant.

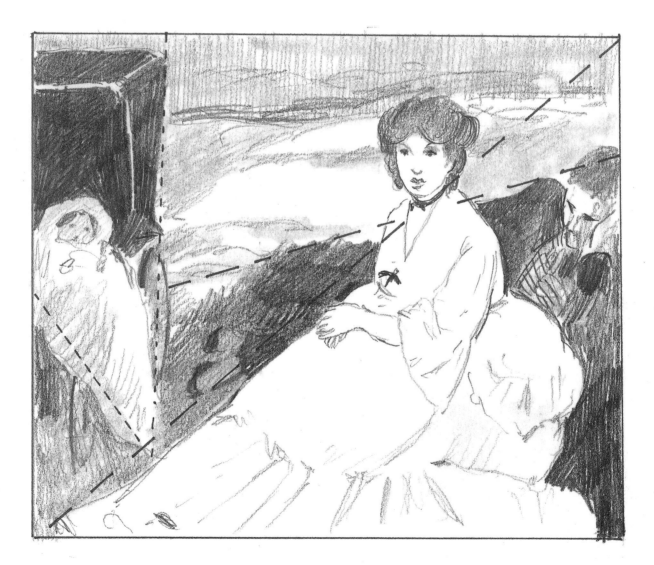

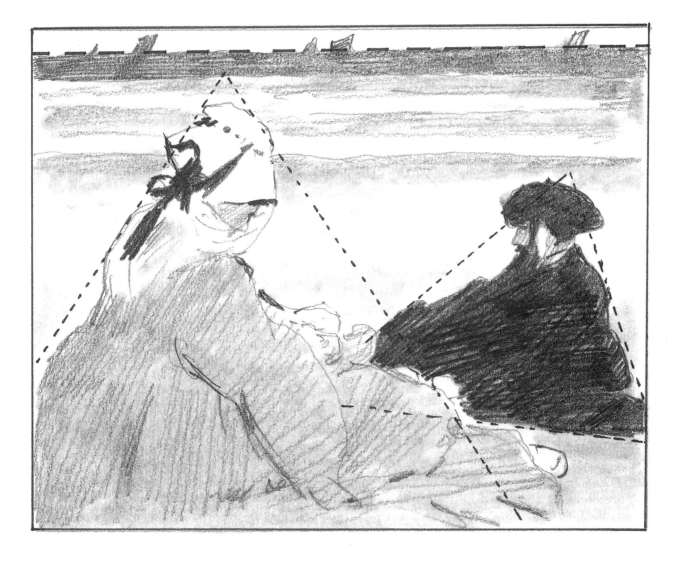

Whereas the first picture had no horizon to speak of, this second Manet, *On the Beach: Suzanne and Eugene Manet* (1873), features a high horizon line that places the area occupied by the sea at the very top of the picture. The male and female figures are composed into larger and lesser triangles that 'answer' each other, although again the female figure is in the larger, more dominant triangle. They are both set below the level of the horizon, and the larger one sits firmly on the base of the picture.

Creating depth

The next pair of pictures show how a good artist can take up his or her position in the landscape to create an interesting spatial relationship between the viewer and the scene.

In *Le Creux Harbour, Sark* (1858), John George Naish (1824–1905) sets his scene behind the sea wall of a small harbour in the Channel Islands. The rocky cliffs ahead and the large wall to the left, casting a shadow across the water, cut out any deep sense of landscape. Near the foreground some boats are moored, and just about to disappear behind the harbour wall is another boat with two men in it. So although we are aware of how spacious the harbour is, it is carefully circumscribed by the wall and the farther rocks.

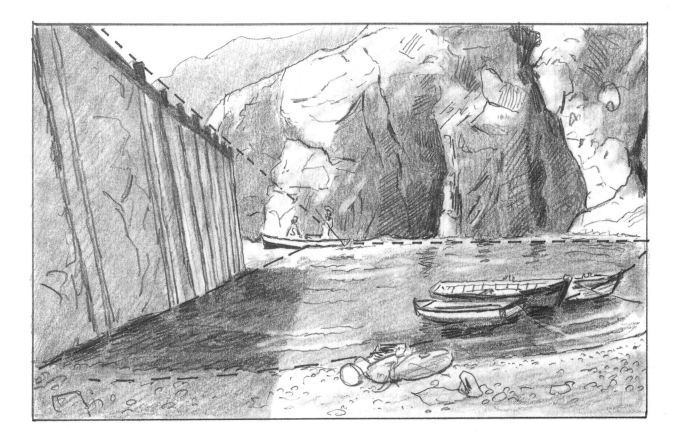

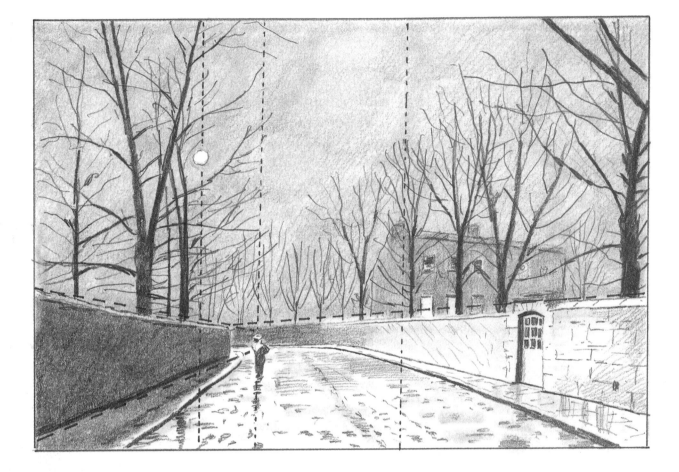

This picture, after *Old English House, Moonlight after Rain* (1882) by John Atkinson Grimshaw (1836–93), is one of his marvellous night scenes where the moonlight plays a significant role. The walls on each side enclose the road as it recedes from our viewpoint, and the bare trees emphasize this movement away from us. The light reflected off the wet road and pavements draws attention to the way the space in the picture takes the viewer in. The vertical divisions that I have marked demonstrate Grimshaw's achievement of depth: the distant moon, the retreating figure, and the house visible over the wall in the distance.

So, as you can see, the use of geometry is helpful and can make the difference between an unremarkable picture and something that really catches our notice. It seems that our minds quite like to consider geometrical propositions, even if we are not totally aware of them.

Perspective

This is the technique of making a two-dimensional drawing – with length and breadth – appear to acquire a third dimension: that of depth. Perspective was the great discovery of the Italian Renaissance artists, based upon mathematical principles. The renowned architect and engineer Filippo Brunelleschi was the man generally considered to be the prime discoverer of the laws of perspective. He painted a picture of the Baptistry in Florence according to his own system of horizon lines and vanishing points.

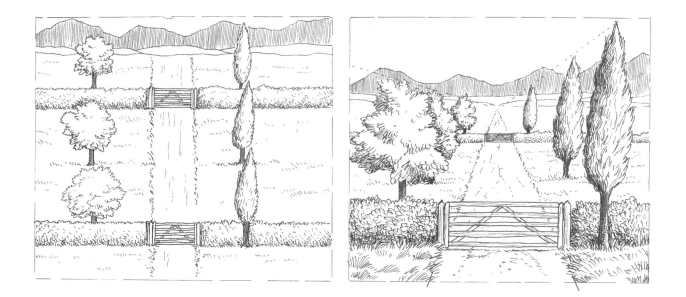

In very simple terms, you can see the difference between the two pictures shown above, one drawn without much attention to perspective, and the other based on the system of single-point perspective, which tricks the eye into thinking that it is seeing depth and space.

Note how the trees and gateways are all the same size in the first picture, whether they are close to the viewer or far away. Also, look at how the road stays the same width even as far as the horizon; nor is there much difference between the texture of the nearest trees and hedges and those further off. The result is the effect of a rather flat landscape.

The second version shows what happens when you devise a method of interpreting the same landscape seen in terms of space. The nearest objects are both larger and more textured than those further away, and already this gives a sense of depth to the picture. The road appears to narrow as it recedes into the distance, eventually disappearing to a single point far off on the horizon. Although this is a fairly simple drawing the effect of recession is immediate.

The cone of vision

This diagram demonstrates the theoretical way that
the system of perspective works.

When we look at any view, there is a field of vision that can be divided into the area
where we see things clearly and – at the periphery – another area where we can hardly
define anything at all. The overall effect is to create a 'cone' of vision, within which
we can see objects clearly, and outside of which we are aware of nothing except light
and darkness.

In the diagram, the figure is standing at a point in space called the 'station point'.
From this point, the figure looks straight ahead at the centre line of vision. The
horizon is naturally at eye level, and where the line of vision cuts across the horizon is
the centre point of an area that includes everything one can see of the space in front.
The circle of vision is that part of the cone of vision that meets with what is known as
the 'picture plane'. This is the area upon which all your images are to be drawn. It is
usually perpendicular to the ground plane
of the surface on which you stand. The
picture plane covers an area containing
everything that could go into your
picture. Of course, you might choose to
crop down your picture area, but it is
possible to draw anything within the
focus of this space.

One-point perspective

When you come to make a picture based on this theory of vision, in a way, you reverse the process and construct a series of shapes based on the centre point, which now becomes the 'vanishing point'. This means that everything in the picture is dependent on the central point of your vision.

To construct these forms you will need a ruler, because straight lines are essential. You will be making an image that has a single point on the eye level, or horizon, to which all lines of depth will be related.

Draw a horizon from one side of the paper to the other and place a point in the centre of it. Then construct three rectangles in the space of the picture, one being entirely above the horizon, one entirely below, and one partly above and partly below it.

Now trace straight lines with a ruler from each corner of those three rectangles to join at the centre point on the horizon.

Having done this, you can now go ahead and construct cubes from your rectangles by drawing a smaller rectangle further along the lines that join the vanishing point, thus forming an apparently three-dimensional form. In the cube above the horizon, you will see the side and underside of the cube, which appears to be floating up in the air. In the one below the horizon you get a similar effect, except that the cube shows its upper surface and side, and appears to be on the ground. The third cube is similar to a building viewed at eye-level, because the only visible parts are the front and side, and it looks as if it is towering over your head. This, of course, is all an illusion, but it is a very effective one.

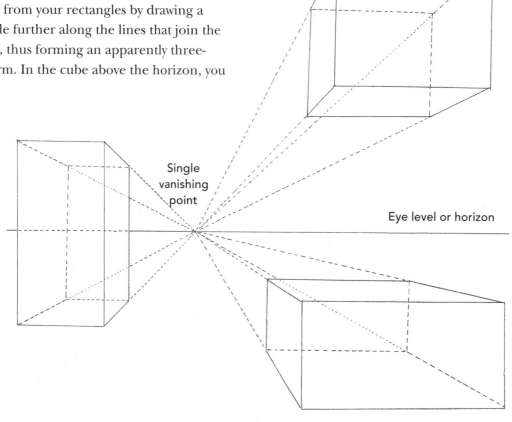

Single vanishing point

Eye level or horizon

Two-point perspective

To take this three-dimensional illusion one step further, if you are looking at objects from an angle you need to add another vanishing point to the horizon.

The next step is to draw a vertical line, which will form the nearest corner of a large block shape that you are about to construct. From the top and bottom ends of the vertical line, draw ruled lines to meet both the vanishing points. Then decide upon the length and depth of your block shape and draw two more verticals that indicate the two corners of the block, making sure that they stop at the lines which join the original vertical with the two vanishing points. Now you have two visible sides of a three- dimensional rectangular block, seen from one corner. I have assumed that your

original vertical, like mine, projects above and below the eye level line. You can see how the object is even more convincing than that constructed on the one-point diagram. Next, produce the second block in the diagram in the same way. I have shaded the sides of the blocks in order to give them more solidity.

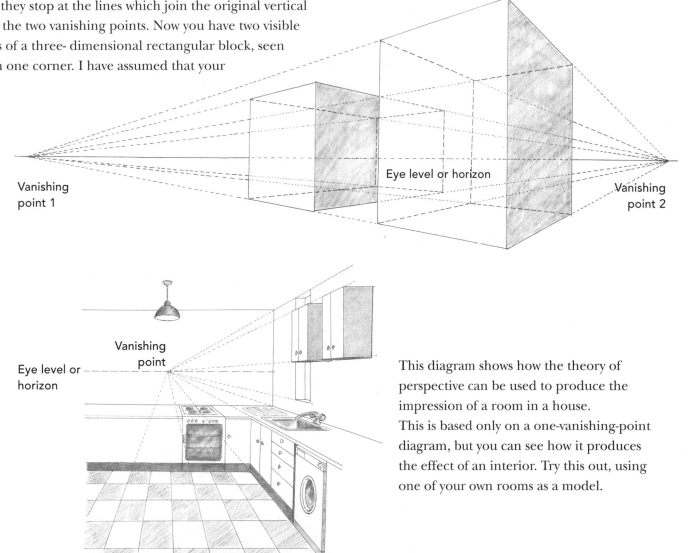

Vanishing point 1

Eye level or horizon

Vanishing point 2

Vanishing point

Eye level or horizon

This diagram shows how the theory of perspective can be used to produce the impression of a room in a house.

This is based only on a one-vanishing-point diagram, but you can see how it produces the effect of an interior. Try this out, using one of your own rooms as a model.

3 STILL LIFE

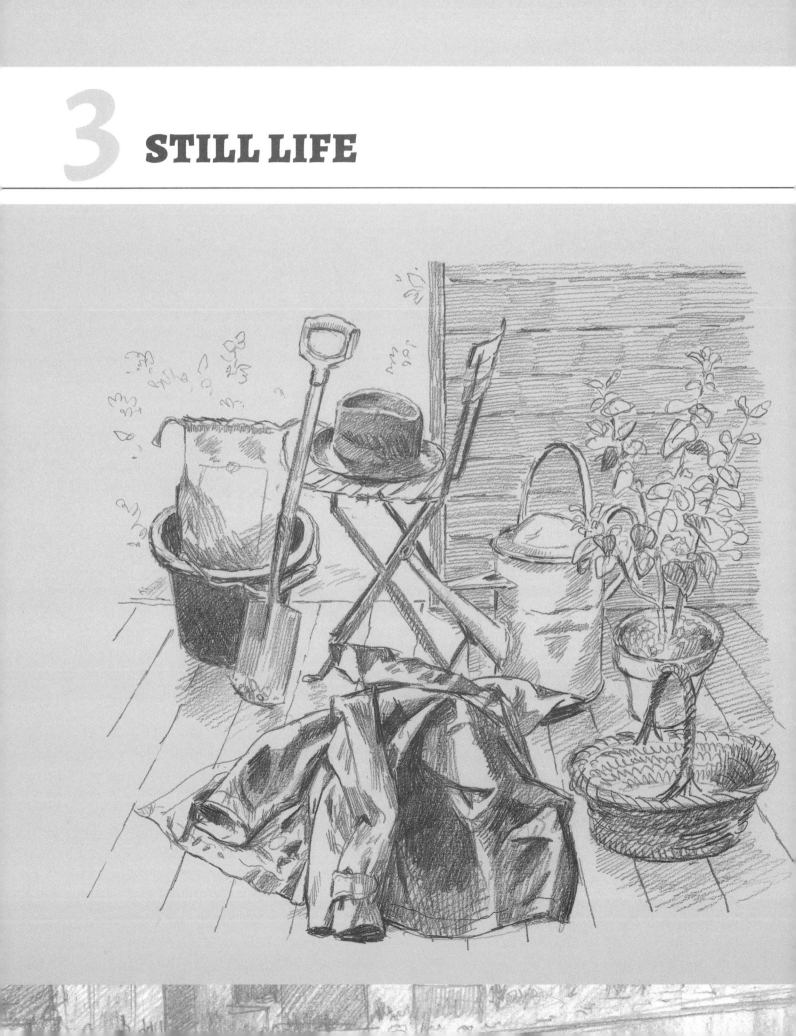

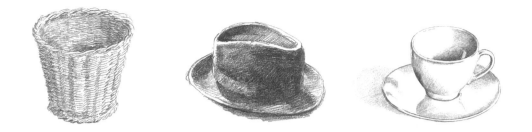

The next section begins our investigations into the area of real-life objects. The idea is to practise your drawing skills by setting up a variety of objects found around your house and making an attempt at drawing them carefully.

The drawing of objects is frequently called 'still life', because the one thing you can rely upon is the fact that your chosen subjects will not move while you are drawing them. Eventually, of course, you will be drawing several objects arranged together so that they make some sort of composition. But before you get to the stage of composing a picture, it is best to draw as many individual items as you can manage, for in drawing there is no substitute for practice.

In order to make things easier for yourself, start with very plain objects. Look for things around you that are relatively simple in shape and texture. Flatter objects are less complex, so begin with items such as knives, forks and spoons, or coins or medals, or even your pencil. None of these rely on appearing very three-dimensional in a drawing, so you won't have a lot of difficulty in making them look convincing. As you progress, try fairly straightforward objects such as cups and saucers, books, tools and jars, then something slightly more complex – shoes or perhaps furniture. Plants are good subjects because they don't move much of their own accord yet are very graceful and have a natural element that man-made objects don't offer.

An important point about all this practice is to draw what you find interesting, and to assume that most things can be interesting if you take the time to look at them carefully.

Simple objects

Embark on your still-life exercise with something that is not too complex, such as a coin or similar object.

Here is a British pound coin. First draw the circular shape as accurately as you can: this is an exercise in itself.

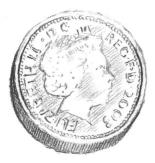

Next, draw the thickness of the coin, as you see it from one side. Then mark out the outline of the head of the monarch and indicate the lettering around the edge.

All you have to do after that is to introduce a little discreet shading around the thickness of the coin and on the face of it, to indicate some minimal relief.

Next we look at a book, which is another item that does not present too many difficulties. First draw the simple structural outline of its box-like shape, creating a little perspective by making the farther end of the book slightly smaller in size than the nearer end.

Then block in the main areas of
shading, to give the impression of
three dimensions.

Lastly, put in details of the tone more carefully and
indicate the pages by drawing fine lines where their
edges show. You now have a solid volume.

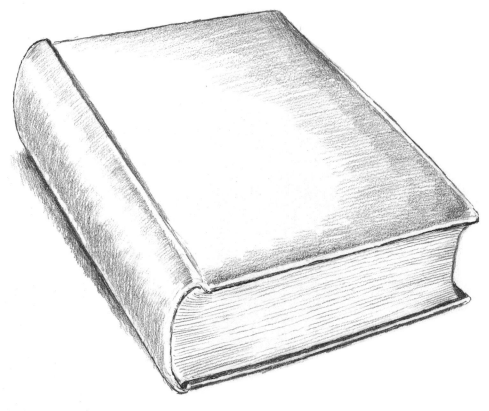

More complex forms

Now try drawing a single workshop tool, such as this pair of pliers. Before you start, have a good look at them. Often, appreciating how something works helps your drawing of it.

First, draw the main outline as before. Don't use a viewpoint immediately above the pliers, or you can't produce a three-dimensional effect.

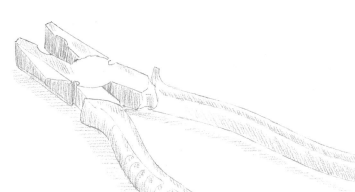

When you are sure that the shape is right, block in very simply all the areas where you can see shading, using just one tone.

Having put in the shading with one tone, you can now add darker tones to emphasize the dimensions and the materiality.

Next, something even more complicated – a pair of binoculars. Start with the main shape, making sure you get all the parts the correct size in relation to all the others.

Again, block in the shadow using the lightest tone. Now work up the darker tones, until your drawing starts to look like the shape and material of the original. Watch out for any reflections, which you should leave white.

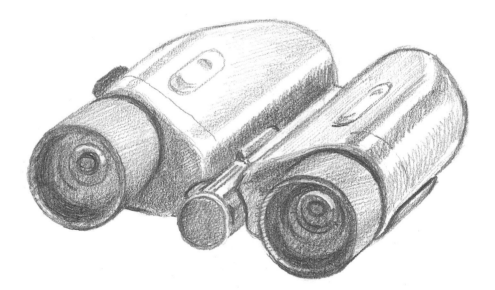

Working up the single object

Next I have chosen a cup and saucer, because this pair of closely fitting objects is fairly simple but has enough complexity to be a good test of your newly acquired skills.

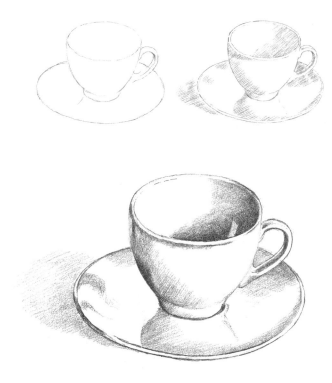

First draw the ellipses to show the top and bottom of the cup, and the main shape of the saucer. Draw the handle shape and the curved sides of the cup.

Put in the main areas of shade with only one tone, as before. Pay attention to the inside of the cup and to the tones on the side of the saucer.

Lastly, work up the tones until you get a good likeness of the shape and reflections on the objects.

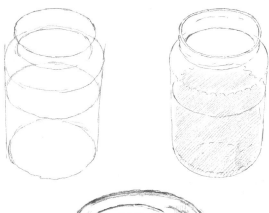

The next object is a glass jar containing tinted water. As before, draw the ellipses and outside edges of the jar, not forgetting to indicate the level of the water as well.

Shade in the area that represents the tinted water. There will not be many other tones, because of the transparency of the glass.

Now indicate all the very darkest parts and also show the difference between the body of the water and the surface. Most of the darkest tones are around the lip of the jar and the indentations in the glass at the top and bottom.

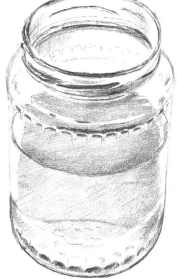

For your next object, take something like a shoe; it will be more complex because of its structure.

Once again, the initial task is to try to get a decent outline of the entire shape, with indications as to where the laces are and how the construction works. Keep it simple to start with.

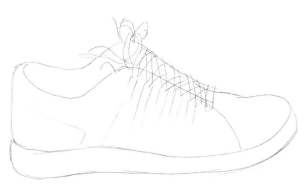

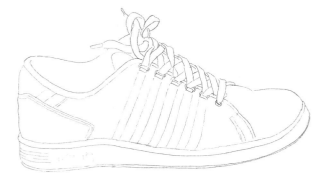

Now, put in sufficient details until the drawing resembles the actual shoe in front of you. The stitching is useful because it indicates the shape of the object as well.

Next, add the tone, only this time use a more textured way of shading, to give some indication of the material; it will be a slightly coarser texture than we have used so far.

Darken the spaces between the laces, showing that there is space within the shoe.

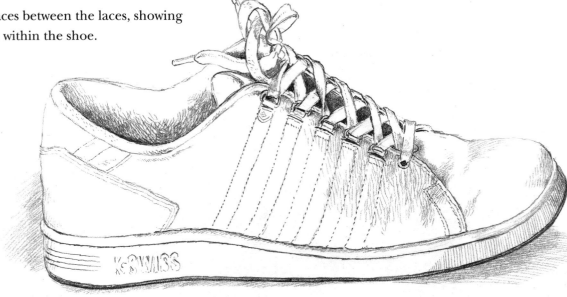

Negative space

This next object is more difficult. This is a child's chair, viewed from an angle that reveals the spaces between the rungs and the back of the chair.

Drawing the first outline is in some ways easier than with a more solid object, because it is quite clear how the chair is constructed. Keep the drawing loose and open to start with, so that you can link the legs and rungs across the main structure.

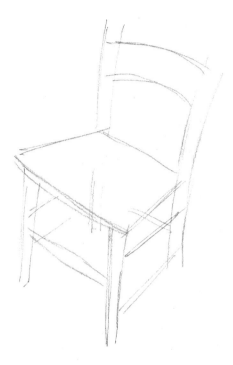

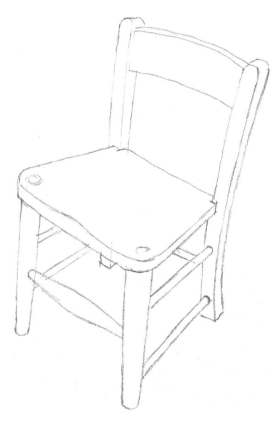

Then, firm up the drawing by outlining each part more precisely.

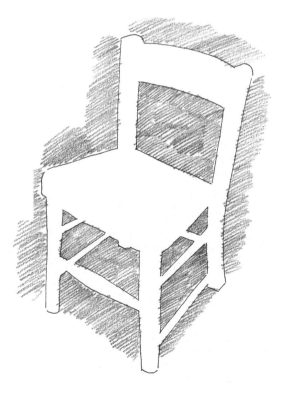

The diagram shows the negative spaces drawn in: careful observation of the spaces between the parts of the chair will enable you to check your drawing; if the spaces are not correct then you know that you have some part of the basic structure wrong as well.

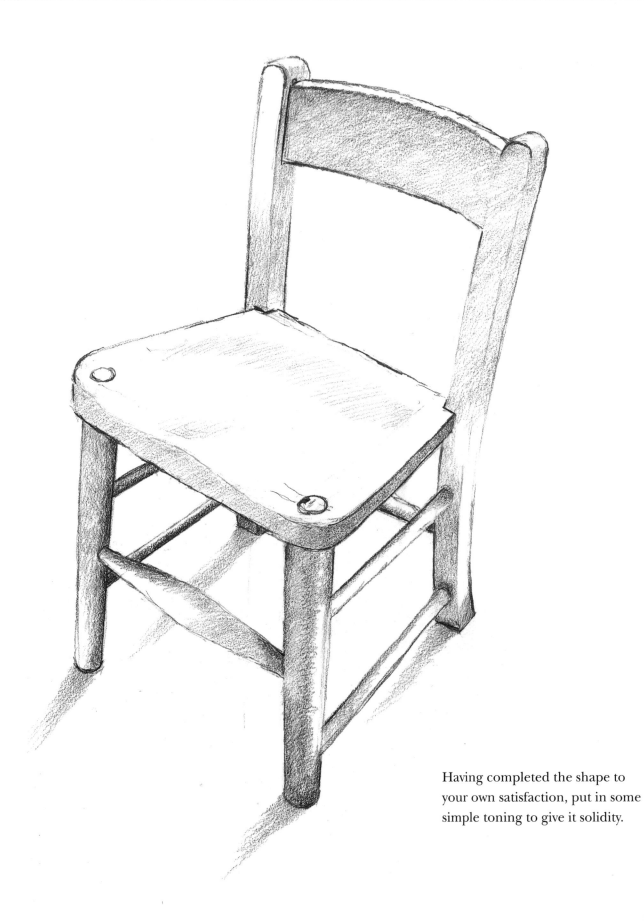

Having completed the shape to your own satisfaction, put in some simple toning to give it solidity.

Materiality 1

With any object you draw, you need to indicate its texture and material to the viewer. You can do this by means of showing light and shade and choosing the type of marks you make. Here are some examples.

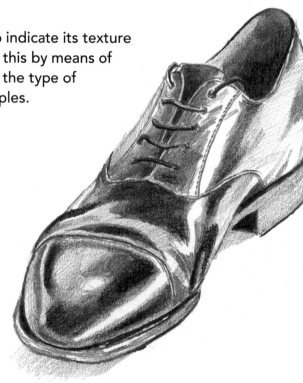

Leather – matt or shiny

This particular shoe is dark and well-polished, so there are strong contrasts between the light and dark areas. Study it quite carefully and observe how those light and dark areas define the shape of the shoe, as well as its materiality.

Notice how the very darkest tones are often right next to the very lightest, which gives maximum contrast.

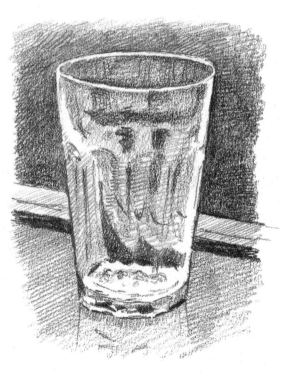

Glass – transparent and reflective

The shape of this tumbler, set against a dark background, is defined by the glass picking up all sorts of reflections from the surrounding area. Notice how a section of the straight edge behind the glass is visible but in a distorted (refracted) way, due to the thickness of the material and its curved surface. Make sure that when you draw the outline of the glass it is well delineated, because this outer shape holds together the rather amorphous forms of the reflections. Also, note how the brightest highlights occur in only one or two small areas. Don't be tempted to put in too many highlights or the tumbler won't look so airily transparent.

Metal – strongly reflective

The metal object I have chosen is also a highly reflective piece of hardware – a shiny saucepan. Once you have drawn the shape as accurately as you can, you have to decide how much of its reflectivity you are going to show. Reflections on this type of surface can become very complicated to draw, so it is a reasonable decision to simplify them to a certain extent. Make sure you represent all the main areas of dark and light and, as before, that the very brightest is placed next to the very darkest. The interior of the pan is not so clearly reflective and you should show the difference between the inside and the outside. The cast shadow is important, because that is also reflected in the side of the pan and helps to reinforce the illusion.

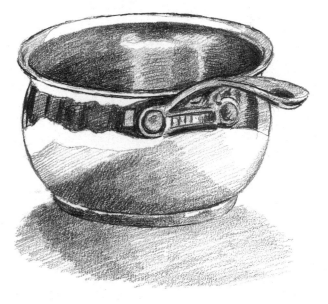

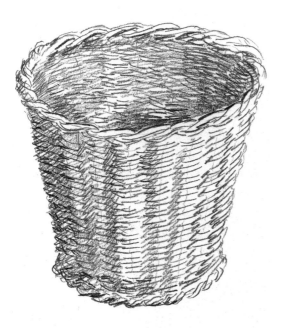

Basketwork – strong texture

This particular texture needs careful drawing in order to achieve the best general effect. On the plus side, the shapes of the woven strands of basket are quite repetitive in nature, so once you get the hang of it, it should not take you long. When the pattern of the basketwork has been completed, the shadow on the inner part and down one side should yeild a three-dimensional aspect.

Materiality 2

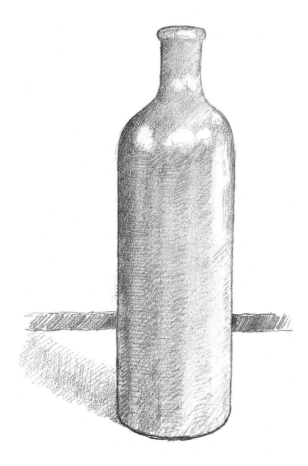

Pottery – hard and smooth

This pottery bottle shouldn't be too difficult because the surface is not as reflective as previous objects, and the shape is simple enough. Just make sure that the gradation of tone around the bottle doesn't look too harsh, and a little texture created by the pencil as you stroke it round the contours helps to mimic the striated surface.

Textiles: silk – soft surface

A silk handkerchief is the next item and, again, is not so difficult to draw, although it does require careful rendering in even tones. Folds occurring in silk fabric tend to be rounder and softer than in any other material.

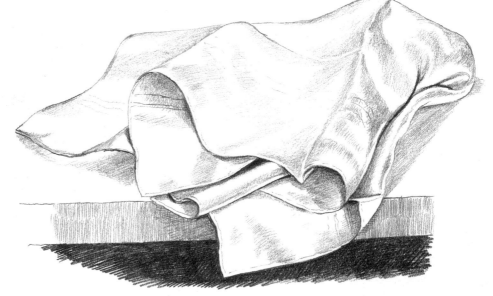

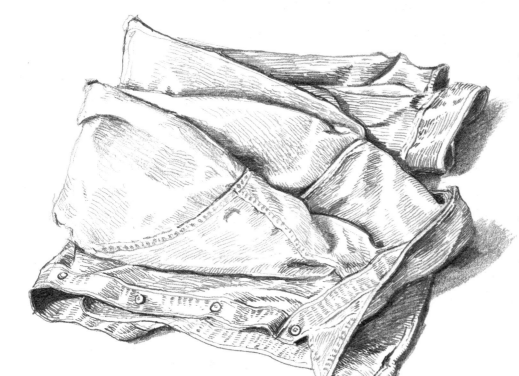

Textiles: corduroy – tough texture

This corduroy shirt is made of a fairly stiff material and that should show in the way that you draw the folds. It also has a distinctive surface texture, which makes it look very different from another, smoother fabric. Don't delineate every cord on the surface, just in the shadowy areas where the tone is deeper.

Paper – crumpled surfaces

Unlike most of the fabrics that we wear, crumpled paper exhibits quite sharp folds and this will be the chief way to differentiate it from textiles. The other characteristic of most paper is that it reflects light well, and consequently there are very few deep shadows. Drawing crumpled paper is an interesting exercise that is often used in art schools.

Seeing the structure of still life

Here are a few ways in which to simplify the arrangement of still-life groups when faced with a collection of objects.

First consider rectangular objects and note how the position of each block relates to the perspective view. This will help to place them in some relation to each other.

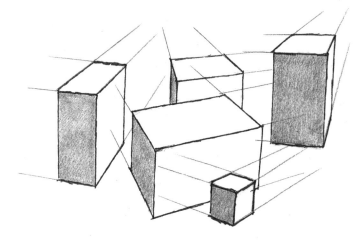

In this drawing, the blocks have been replaced by objects such as books, boxes and a table. The one thing that they will have in common is the eye-level.

The next group of objects is based on the shape of the cylinder, a common feature of many still-life objects chosen by painters. The main thing to observe here is to connect them by their perspective and also their roundness of form.

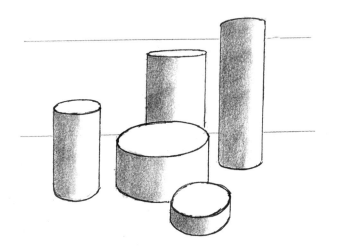

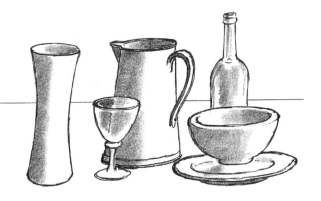

These objects are a vase, wine glass, jug, bottle and a bowl and plate. They all present elliptical shapes and that factor helps to hold them together.

The next group is based on spheres, which of course means that you will have to look carefully at the way that the shading indicates the form.

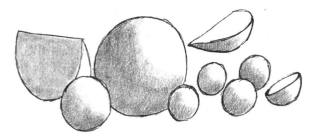

Probably the most frequently used spherical objects in still life are fruits. Here are a pumpkin, melon, lemon, apples and oranges – and an egg, for practice. Cross-sections give added interest and reveal fascinating patterns.

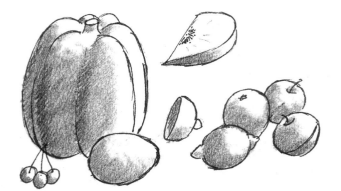

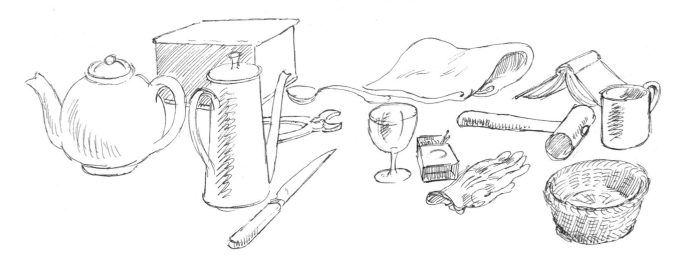

Looking at a whole selection of objects that might be used in a still life, you will see that the variety of shapes makes for even more interesting arrangements. Sometimes you might limit the shapes to a few that appear sympathetic to one another; at other times you could contrast them as radically as possible. But whatever you choose, you have plenty of scope for very different effects.

Some still life approaches

Here I show six ways of approaching still-life subjects, and although this is not by any means the end of the story, they will give you some idea of the variety of choice.

The first picture (right) concentrates on a single shape and repeats it several times in a group at the centre of the composition. All the objects are cylindrical and close in size to one another. Nothing stands out on its own; it is the group that matters as a whole. There is no theme, except for the aesthetic satisfaction that it gives to the eye.

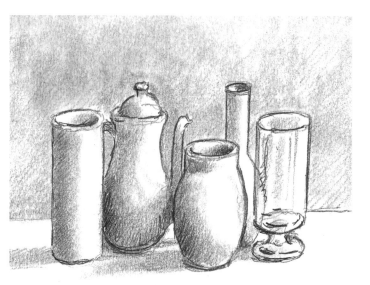

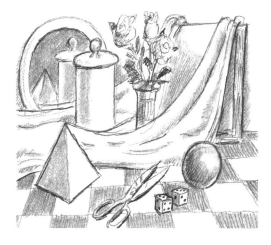

The next picture (left) is not themed either, but is an attempt to create an interesting composition with objects unrelated to one another, except possibly in size. The idea is similar to the first picture, but with objects of different shapes spread out across the space more extensively. Here the particular quality of each object is important in producing an interesting group.

This example (right) is a themed composition using objects associated with cooking a meal. There are various foods such as fish, bread, tomatoes and cabbage, along with necessary kitchen items such as saucepans, cutlery and condiments. So there is a sort of story to the picture, which suggests that we are witnessing the initial stages in the preparation of a meal.

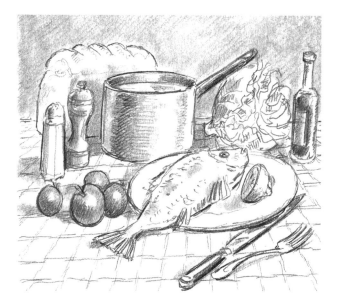

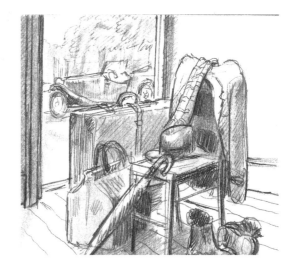

The next example (right) is also themed but with a less enclosed look to it because we can see through a doorway to a drive beyond the room, where a car is standing. This suggests that someone is about to go off on a journey or has just returned from one. All the objects seem to be related to travel in some way.

The next picture (left) is a type of themed composition but less 'arranged'. It has the look of a random collection of items left by someone who was recently present. It could be a group of objects that you might see lying around untidily at home, not yet cleared away. The treatment of space is crucial and the objects take on added importance.

The last picture is more symbolic than the previous examples because it seems to hint at art and literature being like a candle and shining light upon us. The arrangement covers the whole area and each object is part of the message, including the vase of flowers, which adds the right natural note to the still life.

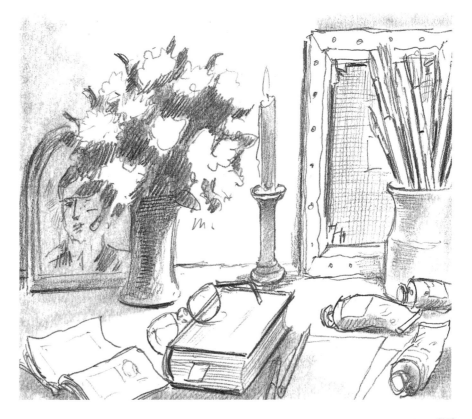

Still life project: Step one

While considering this project I looked around my own house and garden to choose objects that would be readily available in most households. I finally decided that I would set up a still life with a gardening theme as the objects would be fairly large, with a good range of texture and form.

Choosing the objects

First of all, I drew this plant that was growing in a pot outside our back door. This gives a natural feel to the arrangement and prevents the theme from being too man-made.

Next, I noticed this battered old watering can standing by our water butt, and it seemed a rather nice object for a drawing. Its dented sides had a well-worn look.

Immediately to hand was a folding metal garden chair, and this was a very useful piece because I could put things on top of it if I wanted to.

I went to the garden shed to see if there was anything that would make an interesting contrast to the things I had already gathered together. Inside the shed there was a spade and a bucket with some compost in a bag inside it, which looked somehow ready to use.

Up on a shelf, I found a couple of baskets and took one down to use in my composition.

Still life project: Step two

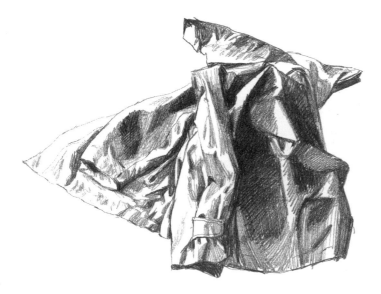

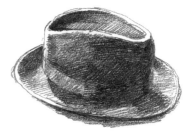

Then I went inside the house for a moment, thinking that perhaps some clothing associated with working in the garden might be a good idea, because it would add a human, just-been-here touch to the scene. So I selected a waterproof jacket and an old hat as part of this arrangement.

I had eight objects associated with gardening, and I now needed to look at them all together to see if I could arrange them in a way that looked natural, as if it might have occurred without design.

Checking out the composition

I first put my objects down in the doorway of the garden shed, with the metal chair in front of the open door and the waterproof jacket and hat slung over the back. Then, in front of these, I laid the spade on the ground and placed the basket and watering can in front of that. I stood the potted plant at the side of the chair. This looked suitable for a drawing, but I wanted to try out some other arrangements as well.

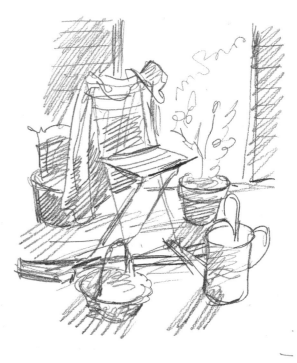

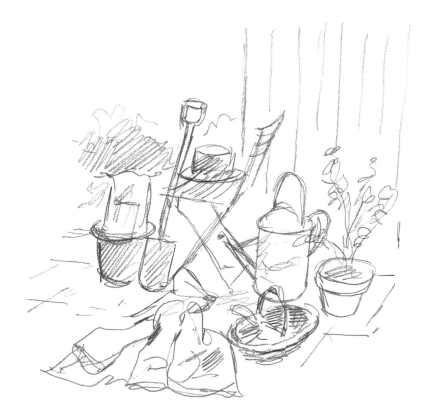

My second trial arrangement had the chair in the doorway of the shed again, this time looking through it, with only the hat on the seat. I leaned the spade upright against the chair and placed the bucket with the compost bag next to it. On the other side of the chair I stood the watering can and beside that, the potted plant. I placed the basket in front of the can, and lastly I threw the jacket on to the floor of the shed as though just discarded. This seemed a bit better than the first arrangement, because I had been making quick sketches of them as soon as I had put them in place. I could also have photographed the objects, in order to remember what the arrangements looked like.

The third attempt at a composition brought everything much closer together, with the chair draped in the coat and the hat hanging on its back, the spade leaning on the chair, the watering can in front of it, and the bucket with its sack of compost and the basket almost tucked behind the chair. The potted plant was half hidden behind the watering can. I did not feel very satisfied with this arrangement and returned to the second one, which I felt held more promise.

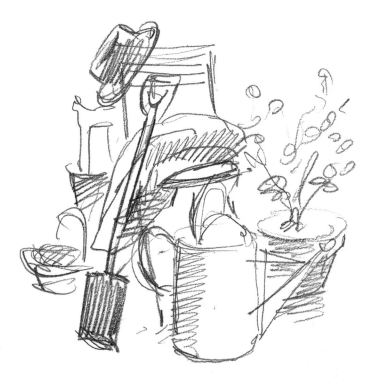

Still life project: Step three

The final set up

Once again, I put together the objects in the second arrangement and this time I noticed how the light coming in from the shed doorway produced an interesting effect. Carefully drawing the whole thing, I first made sure that the relative sizes and proportions of all the different objects had been observed properly, and that they overlapped one another in a pleasing way. How you decide to achieve this is up to you, but do remember that when objects overlap in an arrangement, the amount that remains showing is important and should not look awkward.

Now it is your turn to choose your objects and have a go at this exercise. It is quite good fun because you decide how the final composition is going to look, and that is part of the creativity of drawing.

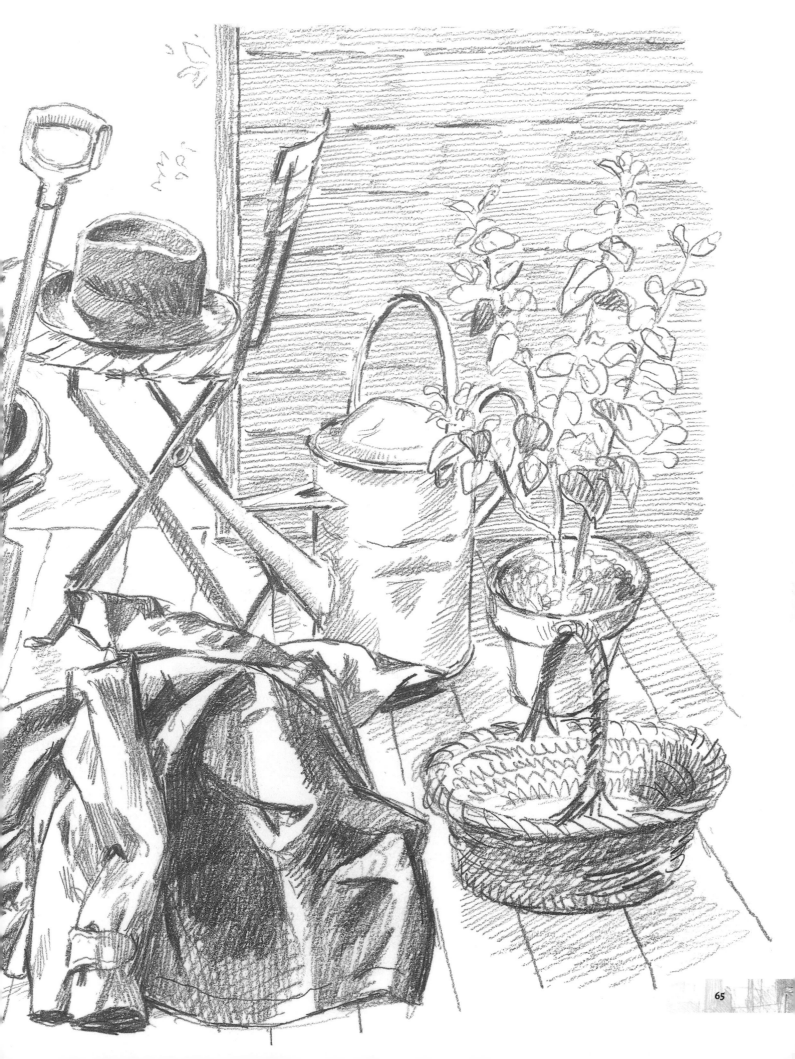

4 LANDSCAPE

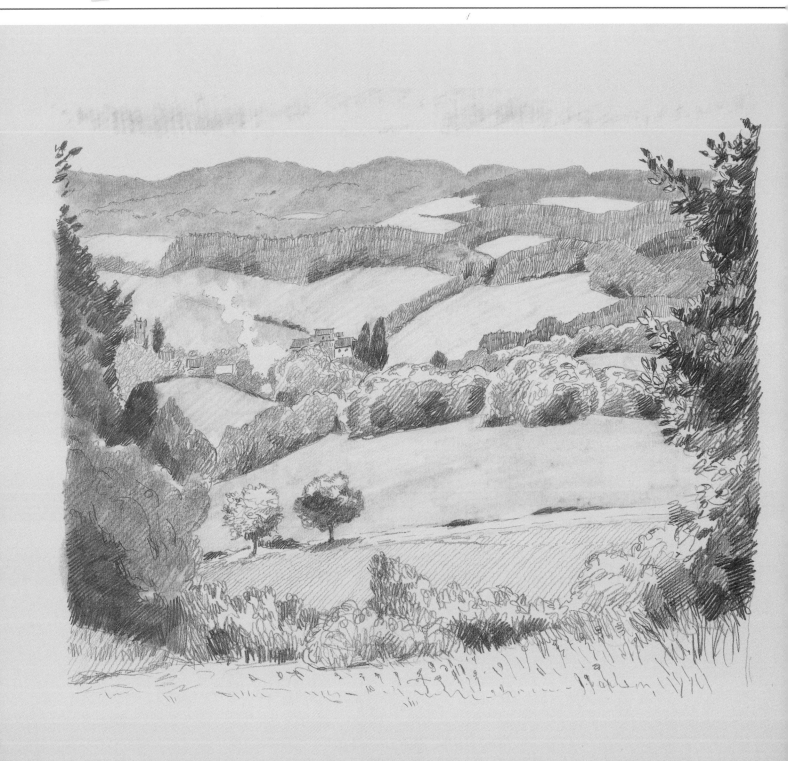

The landscape genre is hugely popular with artists, both novice and professional. This is partly because most people like to spend time in nature, and if you are an artist the natural response is to want to translate it to paper or canvas. The other attraction is that you can often revisit the same place and find your subject just as you left it, should you need to do further work on your drawing. Returning to the same spot is in fact a good discipline, since the weather changes – sometimes radically – and so the same scene can present itself in many variations of light and dark.

Another great advantage to landscape drawing is that unless your friends are actually seated alongside you, they will not be aware of any of the things that you may have altered to make your picture more interesting or easier to draw. It will still look like a genuine landscape as long as your perspective is correct and the vegetation is reasonably well drawn.

You do not have to travel far, since there is a landscape waiting to be discovered immediately outside your house. It might be the view from your window; the garden behind your house; or the street in front of you. Somewhere nearby there may be a park, or gardens open to the public. Perhaps a short walk or drive from home will bring you to open countryside. You don't have to go to a specific area of natural beauty that artists have painted before; the artist learns to see beauty anywhere, even in the most unlikely circumstances.

Going on holiday always provides a good opportunity to explore a landscape that you may not have seen before, so don't forget to take some sketchbooks. These are invaluable for an artist, because a record can be made on the spot of any thing or place that attracts the attention. Equip yourself with a handy pocket-sized sketchbook, as well as a larger one for more considered expeditions.

Rocks and mountains

Tackling a landscape may seem daunting, but if you can draw the smaller elements in it the larger ones will present no problem. Imposing mountain peaks are no harder to describe than a rock you could hold in your hand – the difference is merely one of scale.

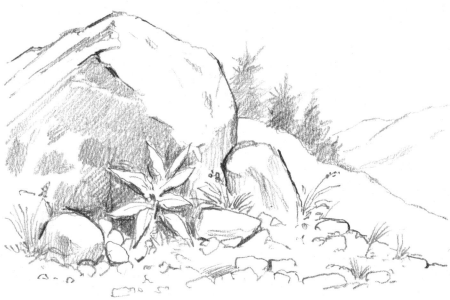

Here you can see that the angles and planes of the large rock are echoed in the smaller rocks and stones that surround it. It's easy to give them a three-dimensional appearance by shading the areas that are away from the light – but take care to be consistent with the angle of light or they won't look convincing.

The varying shapes of these boulders make an interesting pattern, with areas of highlight and deep shade. When rendering this type of stony composition, indicate the lines of texture according to the way the various geological layers are arranged.

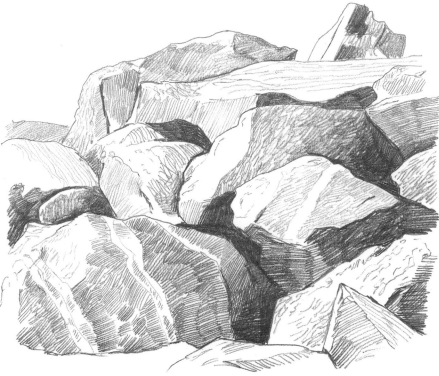

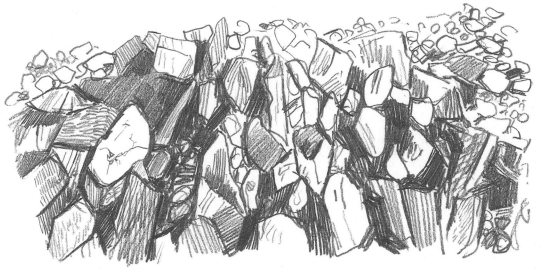

Next, turn your attention to a stony surface made up from pieces of worn rock heaped together. The main thing to notice here is how the different shapes lie in all directions, thrown together in no particular order.

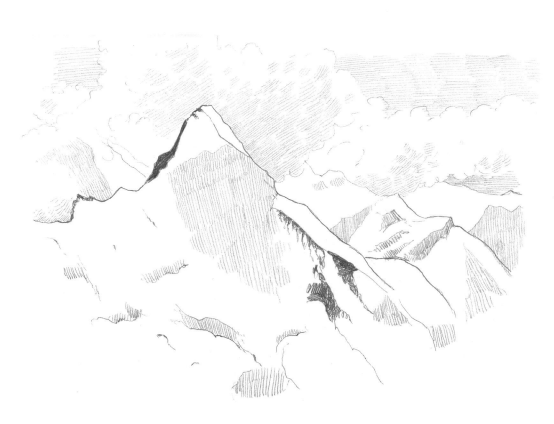

For snow-covered alpine peaks, leave a fair amount of untouched white paper to represent the snow. Where the rock beneath shows through, it will appear much darker by contrast. Take care not to overdo the texture on snowy surfaces, otherwise they will look as though the snow has melted.

Vegetation

The vast majority of landscapes are largely composed of vegetation of various kinds, and the detail with which you draw them depends on the context. The broader the sweep of landscape, the less you need to indicate beyond describing the overall form that the viewer will identify. In close-up, more detail will precisely convey the characteristics of individual leaves and flowers.

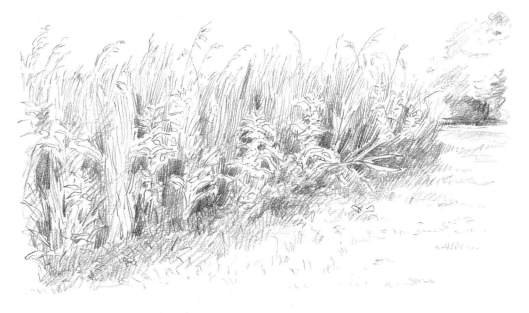

Here is a profusely growing mass of reeds on the edge of some wetlands. The tops of the reeds set against the sky and the darker masses of mixed plants lower down in the foreground help to make this appear a dense barrier of leafy growth between the water and the ordinary grassland. The vertical lines of the reed shapes and the more leafy plants contrast with the shorter grass, which has more light on it.

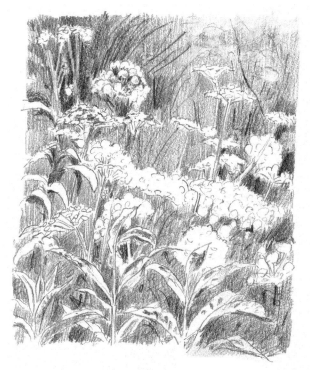

In this drawing the flowerheads of various plants are seen more clearly against the darker mass of long grass. Species such as meadowsweet with masses of tiny flowers give an effect of froth on the top of the vegetation.

These smaller leafy plants are growing beside some fast-flowing water, their flat open leaves contrasting with the the rippling surface. The main difficulty here is to define the leaf shapes clearly against the alternately light and dark water.

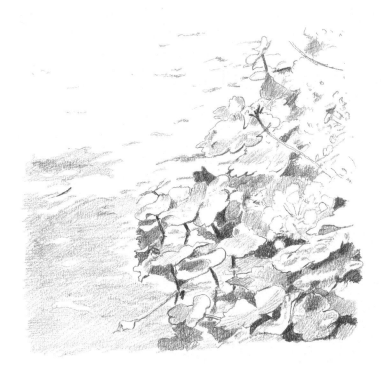

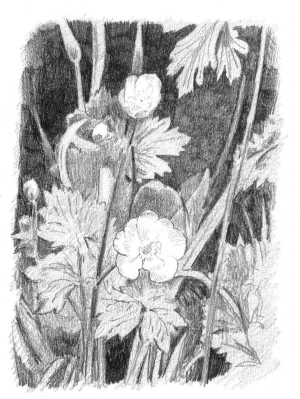

Now, a close up of some bright buttercups shown against the darker mass of grassy background. The edges of the petals are clearly defined and the leaf shapes are darker in tone. They are thrown forward very effectively by the very deep tone of the spaces between them.

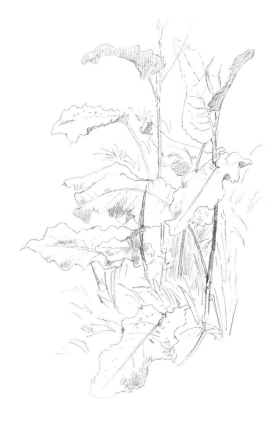

Here are some larger leaves with curving edges, pushing out in various directions from their stems. The undersurface of the leaves is shown a tone or two darker.

Trees in the landscape 1

Trees are an important feature in most landscape drawings and paintings. Here you can see them treated in different ways by different artists, showing a few of the possible approaches.

Applying shape

This example after the British artist Ramsay Richard Reinagle (1775–1862) is in that tradition of landscape drawing where the artist draws in a refined sort of scribble. It is used by Reinagle in *Loughrigg Mountain and River Brathy, near Ambleside – Sun-Set* (1808) to produce a texture that resembles foliage seen from a distance. Notice that, except for the dark lines of the trunks and main branches of the trees, the rest is constructed from a closely repeated pattern of scrawling lines. He occasionally makes it heavier but in the main he has effected a similar texture all over.

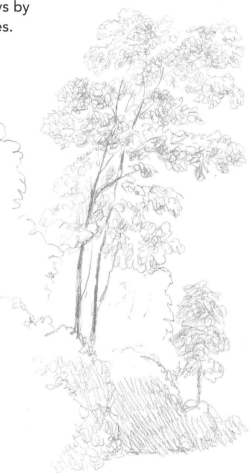

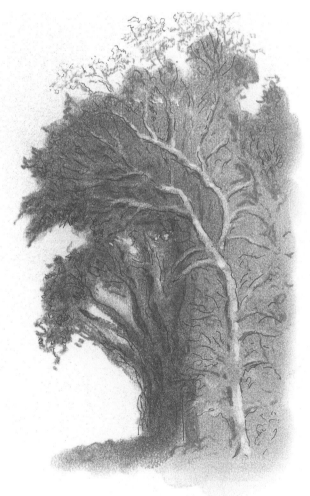

This example, based on a work called *The Valley Farm* (1835) by the painter John Constable (1776–1837), is rather more substantial and has been produced here by first drawing the darker background trees in charcoal – smudging them to give a smoky effect – and then later drawing out the lighter shapes of the closer trees with a kneadable eraser (putty rubber). This method has produced a ghostly etched-out shape, which has then been strengthened by applying darker edges to the trunk and branches to give more apparent depth to the picture. It is a very effective technique.

Formality and decoration

The next drawing shows a Persian miniature of a tree in blossom, executed in the fifteenth century. The method seems almost childlike compared with the style of Renaissance drawing, but it is very effective in context. This version had to be made with considerable care, and the balance of leaves and blossoms spread along the branches had to be very well organized in order to work well.

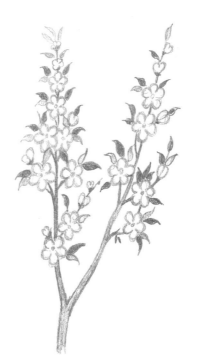

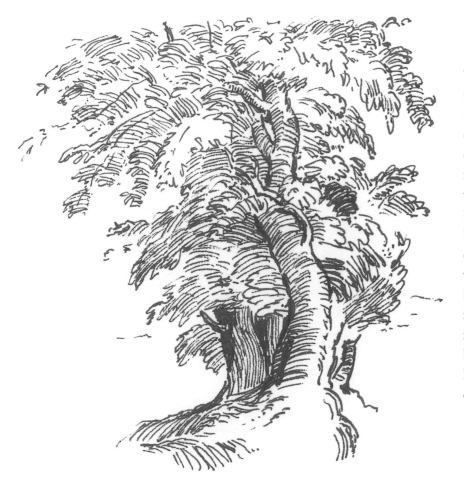

This drawing after Hendrick Goltzius (1558–1617) from *Landscape Tree* (1592) demonstrates a carefully organized method of formalized textural marks, which give the eye an illusion of both solidity and depth. Note how the lines trace the shapes of the tree trunks in varying ways and how the marks that indicate the foliage repeat a feather-like texture, different from the solid parts of the trees but in the same idiom. This helps to create a harmonious effect in the drawing.

Trees in the landscape 2

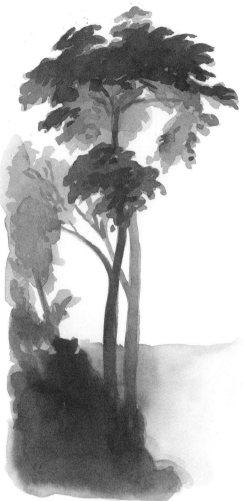

Tonal impressions

These two drawings after J.M.W. Turner (1775–1850) and John Constable bring us to the forerunners of Impressionism.

In *Crossing the Brook* (1815), Turner put his trees in with a brush and the entire picture was copied one tone lighter, with all the trees and the skyline being drawn first. Then, using increasingly darker tones, the picture was built up until the trees in the foreground stood out clearly from the softer-looking background. There are about three layers of watercolour or diluted ink here.

This copy of Constable's impressionistic sketch of trees in *Stoke-by-Nayland* (1810) was done in pencil and heavily smudged to produce a general grey tone. Then, very heavily and fairly loosely, the darker tones were built up over the main tone. If you are outside, drawing from life, do not attempt to put in any detail but just indicate the broad clumps of tonal shape.

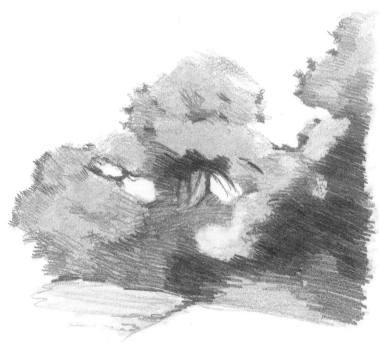

Pattern realizing form

These two drawings of trees after Vincent van Gogh (1853–1890) take pattern-making with marks to a new level.

The first is of a fruit tree in Arles (1889), and here Van Gogh has drawn the trunk and main branches quite distinctly and surrounded them with a pattern of loose, scrawled marks to indicate the tree's leaves and blossom. You cannot see the foliage in any detail at all, yet somehow, the whole effect is of blossom and leaves lit up by the strong sun.

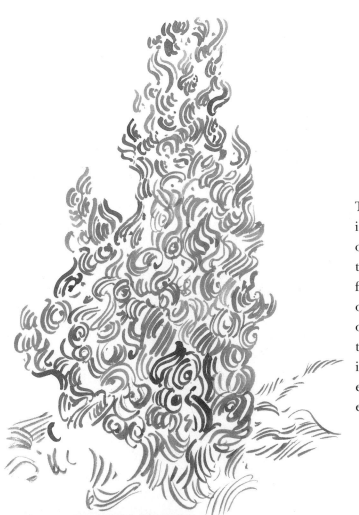

The second example is even more dramatic in its use of pattern to create the impression of foliage. Here is one of the cypresses of the Midi (1889) that Van Gogh made so famous, reduced to a simple repeat pattern of swirling brush marks that seem to grow out of the ground and leap upwards into the air like flames. This reduction of shapes into a repeated texture of marks can be very effective when the artist has seen the essential quality of the object.

Landscape variety

Here are a few examples of how you might approach various scenes.

In this view, the landscape takes up almost the whole area of the picture, leaving only a small strip of sky at the top. This is a typical high-horizon view, and eliminates very much interest in the sky. It is the way that you tend to view a landscape when you are in an elevated position. Because you can see more, you will want to draw more. It may create a mild sense of claustrophobia, but can also lead to a detailed and interesting landscape.

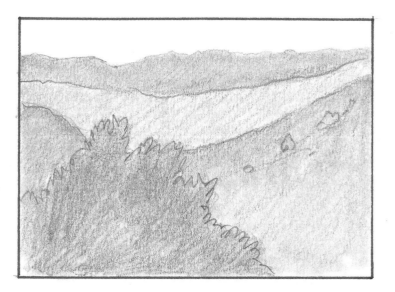

This view is quite the opposite because the observer occupies a relatively low position and the horizon is therefore also very low. This brings the sky into the picture, and you might find it more interesting when there are some good cloudscapes to draw, rather than on a totally clear day. What this view gives is a great sensation of space.

The next one is an interesting mix of a fairly high horizon level and plenty of open space in the shape of the sea. The two headlands are the main feature of the landscape but it is the sea that really forms the picture. The noticeable depth in this view has everything to do with the perceived distance between the two headlands. This sort of landscape also gives you a chance to work on the representation of water.

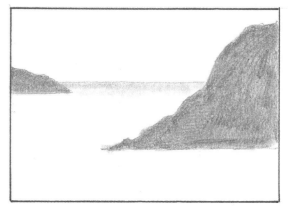

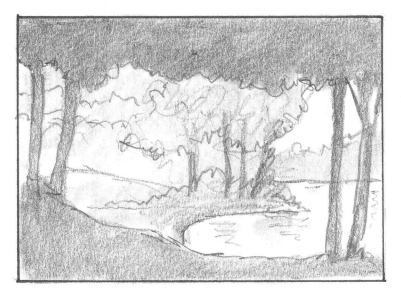

This landscape is enclosed by the grouping of trees around a stretch of water. The viewpoint is from beneath the trees on the bank. The other trees across the small inlet tend to obscure any horizon line; you can just see it to the left, where you get a glimpse of the opposite bank. This composition is almost a vignette because of the frame created by the closest trees.

This is a classic case of a path or roadway pulling the viewer deep into the picture. The fence emphasizes this movement, as does the row of trees alongside the road. They naturally draw attention to the little group of cottages at the end of the path. This is a very popular device used by landscape artists to encourage the viewer to engage with the scene.

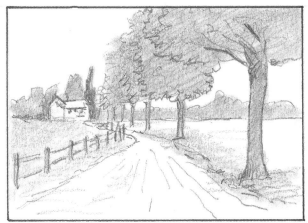

The final example is similar to the image above, but sited in a urban environment. Here, the position in which the artist sets up is critical, because the size and position of the buildings change radically with the vantage point. This is a situation in which a viewfinder (see p. 13) would be very useful. It's a good idea to have the large building on the right cutting into the top of the picture, because it helps to give an impression of greater depth between the viewer and the building near the centre of the picture.

These examples are a taste of the possibilities available when drawing landscapes, both urban and rural.

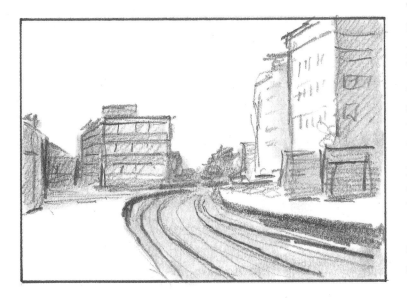

Locating the scene

To show that you do not have to travel vast distances to gain plenty of good landscape experience, the next drawings were made within a few hundred metres (yards) of the same location, situated within a small area of the county of Surrey, England. For some of them, the artist stayed in the same spot, merely turning about 45 degrees. Some were done by walking a little way along a path to obtain a different view; the point is that if you happen to find yourself in a place of great natural beauty, there will be hundreds of different aspects within a very small area.

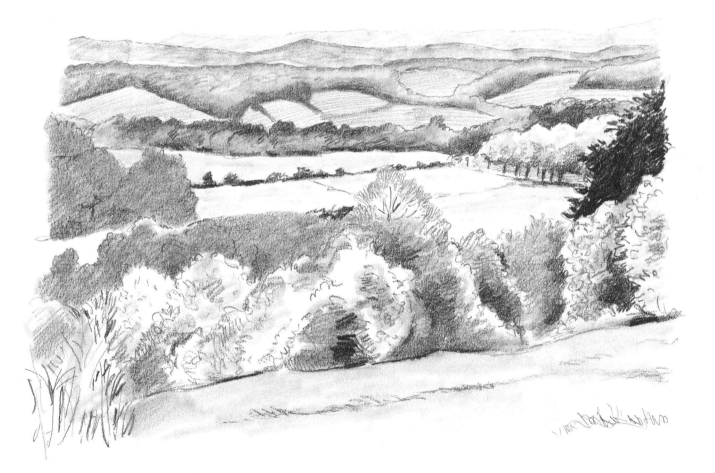

The first landscape view is full of trees and fields that recede towards the misty hills on the horizon. Notice how high the horizon line is, because of the elevated vantage point from which the drawing is being done.

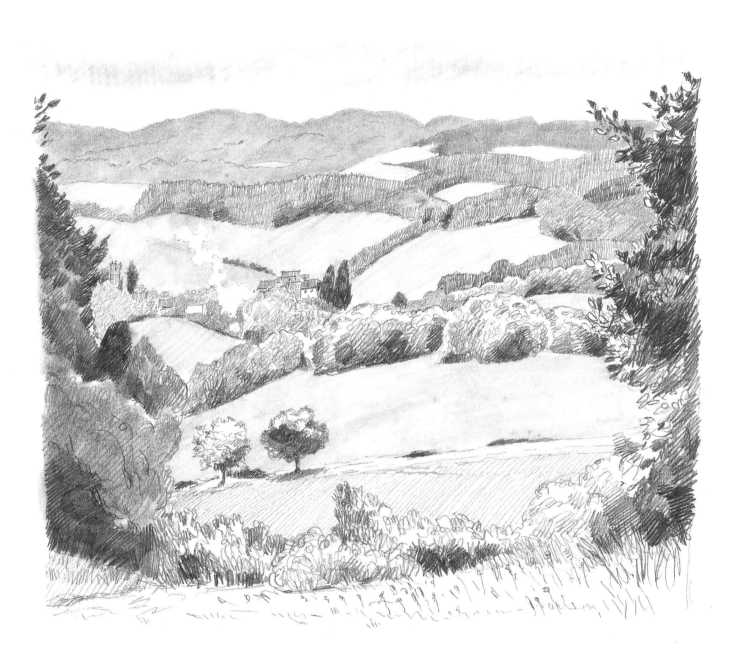

The next picture is similar in concept but quite different in texture and depth. The fact that the view is directly down a fairly steep hill helps to give something else to the scene.

Looking around the scene

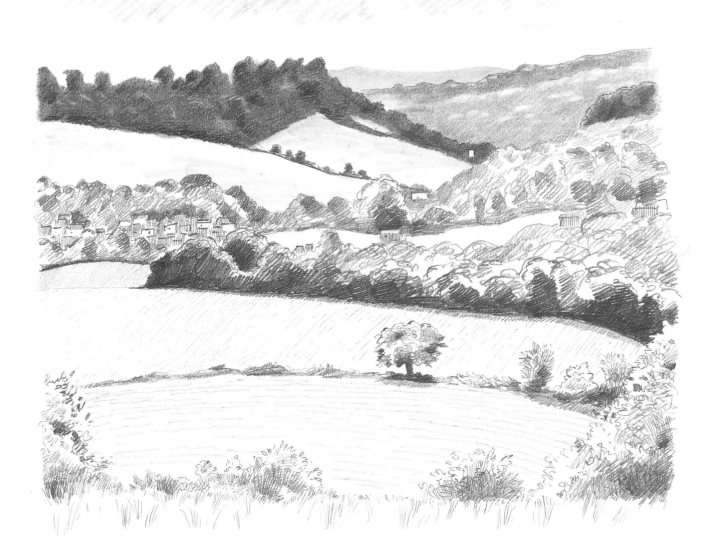

The next one is still in the same area but now the light has changed. The closer hills, topped with trees, are almost silhouettes against the skyline and you seem to be able to look around a corner of the high ground to other hillsides beyond. This is quite a gentle landscape, but can be interpreted dramatically depending on the time of day. The little groups of buildings seen in the middle ground act as focal points.

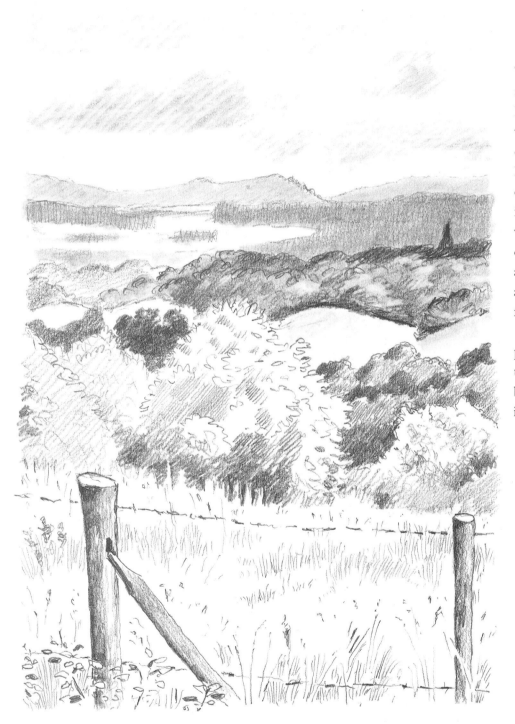

The last drawing is of a place about one hundred yards from where the previous drawings were done. However, it looks very different due to the inclusion of part of a wire fence situated close to the onlooker, and also due to an alteration in format, from landscape (horizontal) to portrait (vertical). In this picture the sky becomes more important.

Dividing up your view

Even when you have found your vantage point, you may be faced with a number of possibilities in terms of composition.

In this drawing, based on a work by the Russian painter Ivan Shishkin (*Young Oaks*, 1886), there is already a well-thought-out limit to the landscape. Nevertheless, you could go one step further and divide this scene effectively into three different landscapes.

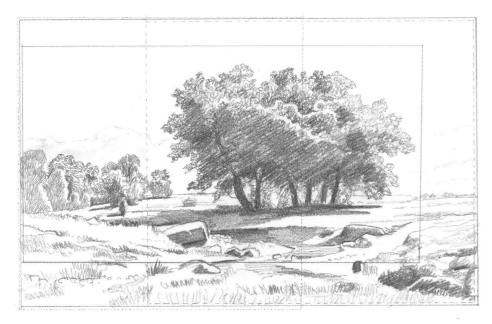

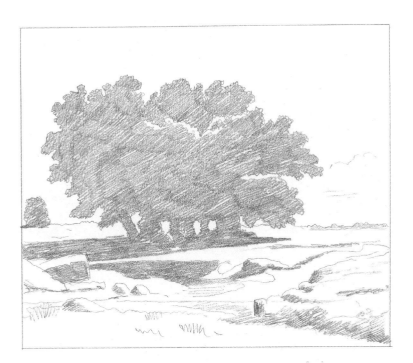

Taking the middle frame first, you would end up with a very strong centralized view of this copse of trees, with just a little foreground to draw the eye into the scene.

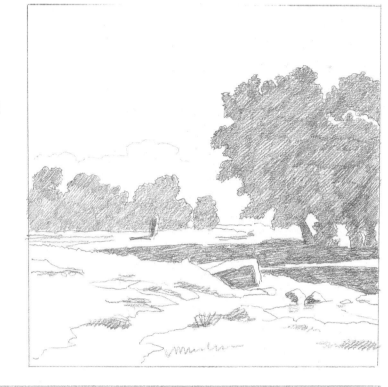

The second version would give you a nicely balanced landscape, with the trees of the copse acting as a dark framework on the right-hand side of the picture. Once more, the foreground would serve to pull your eye in.

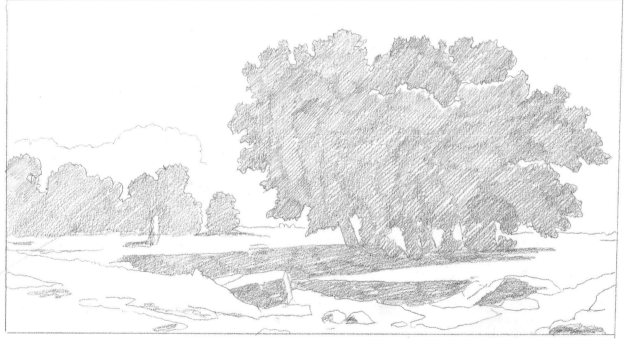

The third version gives us the whole copse again, but this time we have lost a bit of the foreground and most of the space to the right of the trees.

The important thing about this little exercise, with three versions of the same landscape, is that all three would work and produce interesting pictures to look at. So it is always worth taking your time at the outset to consider alternative ways of looking at the landscape.

Landscape project: Step one

Choosing a landscape to draw is always a more difficult proposition than arranging a still life, because you have to go somewhere that you like the look of and this may take some preparation. A pleasant way to do this is to go out for a day in the countryside with friends who will be willing for you to stay behind and draw while they go off for a walk. One day I went with family and friends to look at the old church in Chaldon, Surrey, which has a large medieval mural. While the others spent some time inside with the mural, I wandered around the immediate neighbourhood to survey the landscape.

View A

My first view (A) was of the path and road that swept away from the front entrance of the small church. It was really just a view of trees and the paths and a hedge down one side. In some ways it was almost too simple but I liked the way that the division in the paths created a natural focal point for the whole composition, so I drew it.

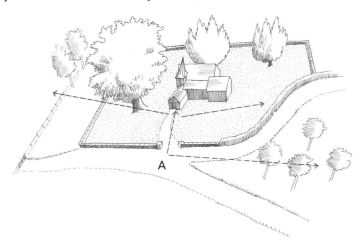

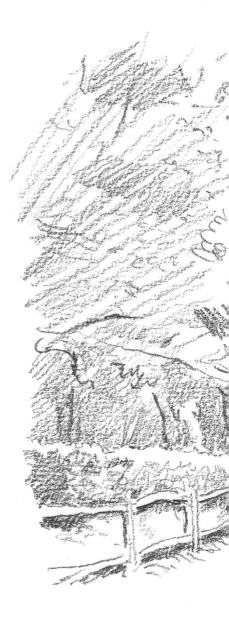

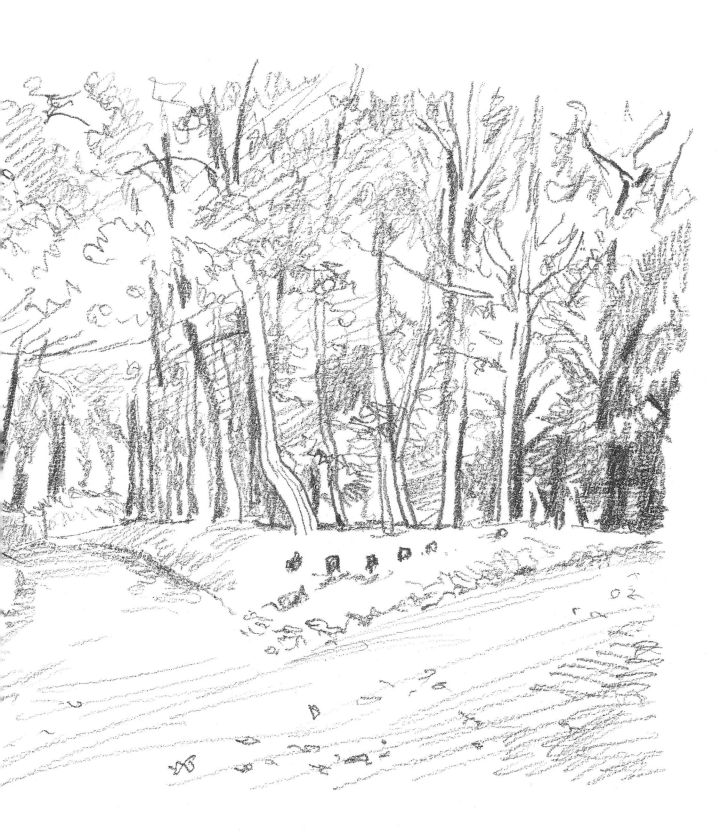

Landscape project: Step two

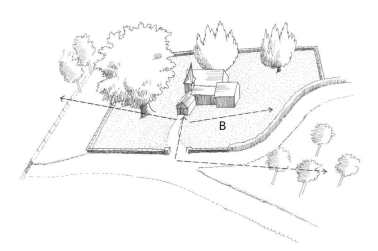

View B

The next view that struck me was from the front door of the church across several gravestones towards some very dark yew trees. This view also took in some of the church wall at the left-hand edge of my drawing. The worn shapes of the gravestones gave a venerable look to the scene, and the dark trees in the background set them off well. There was also a more extended view to one side of the church, which gave focal depth to the composition.

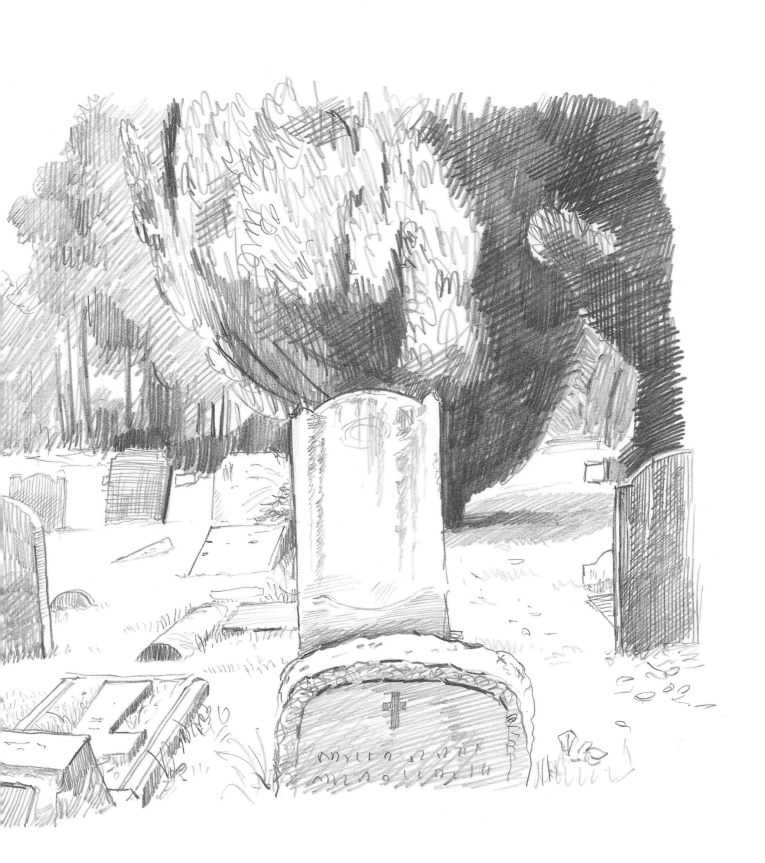

Landscape project: Step three

View C

After view B, I just turned around and looked in exactly the opposite direction, which turned out to be view C. That included a very large, mature tree with a view beyond the churchyard, towards the fields close by. There was a screen of younger trees that formed a backdrop to the mature one in the nearer part of the churchyard. A low wall separated this great tree from the others with a small open space, giving some balance to the picture. It was a fairly grey day, and the mature tree, set darkly against the paler grey of the others outside the wall, made a good contrast.

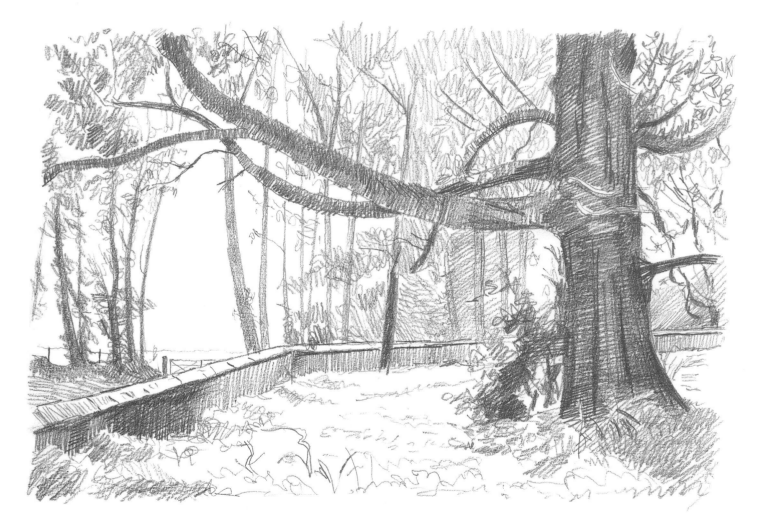

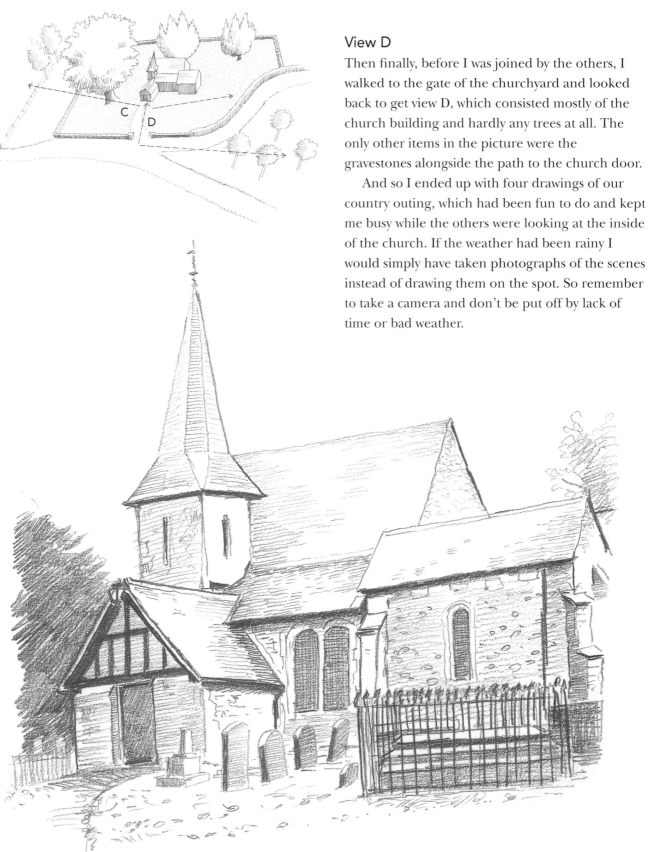

View D

Then finally, before I was joined by the others, I walked to the gate of the churchyard and looked back to get view D, which consisted mostly of the church building and hardly any trees at all. The only other items in the picture were the gravestones alongside the path to the church door.

And so I ended up with four drawings of our country outing, which had been fun to do and kept me busy while the others were looking at the inside of the church. If the weather had been rainy I would simply have taken photographs of the scenes instead of drawing them on the spot. So remember to take a camera and don't be put off by lack of time or bad weather.

5 PORTRAITS

Quite often it is the human face that the novice artist would most like to be able to draw well. It is an excellent way to interest your friends and relatives in your development as an artist, and you will probably find that there is no shortage of people wanting to model for you because it is seen as a compliment that their face is thought worth drawing.

It is immediately apparent to us all whether the drawing of a face resembles the person it is supposed to represent, so while it is one of the most popular areas for an artist to work in, it is also one of the hardest to impress your acquaintances with. This means that a lot of work is necessary in order for you to achieve an acceptable result, but that is one of the reasons why portraiture is so fascinating.

There have been many brilliant portrait painters, so there is no dearth of examples to look at and learn from. You will soon realize that the likeness of an individual is by no means the whole story, for we are impressed and fascinated by Old Master paintings of people who lived many centuries before our own. A good portraitist can capture something of the sitter's personality, and if you can succeed in doing that it will not matter if there is something not quite accurate about a certain feature.

One thing you must appreciate when attempting a portrait, though, is that the shape of the whole head is the key to getting a good result, a fact that many beginners fail to realize. Take care to remember the proportions given on pp.92–93, otherwise the final result might look like a face lacking the foundation of a properly constructed skull.

The proportions of the head

While the exact shape of the head and the size and shape of the features differ from person to person, there are nevertheless basic proportions which you will find echoed in the large majority of people. If this is the first time that you have considered the measurements of the head, you may find them a little surprising.

The first diagram shows that the general proportion of the head, viewed straight on, is in the ratio of 2:3; that is, the width is about two-thirds of the height. Something that most people find difficult to believe at first is that the eyes are situated halfway down the head; this is because most people look at the face alone, and don't take into account the part of the head that is covered by hair.

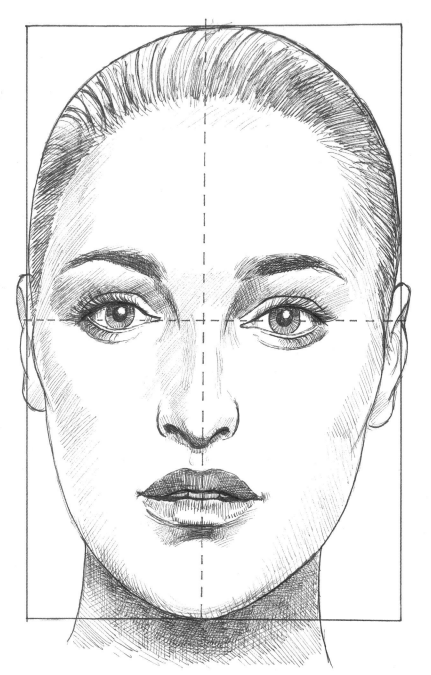

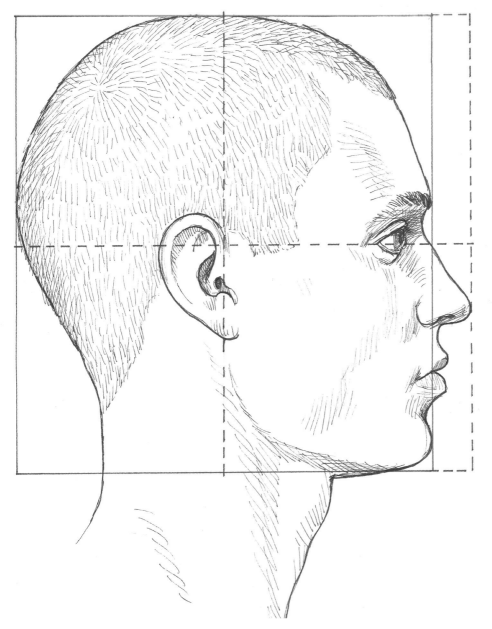

The second diagram shows the side, or profile, view of the head. It measures the same from front to back as it does from top to bottom. The only part that projects beyond the square is the nose, which is obviously variable in size and shape.

Other useful measurements are: the average length of the nose is rather less than half the distance between the eyes and the chin; the spaces between and each side of the eyes, when seen from directly in front, are equal to the horizontal length of the eye. The mouth is somewhat nearer the nose than the chin, so don't leave too big a distance between the base of the nose and the mouth. The ear, seen in profile, lies behind the halfway vertical that bisects the head; it is roughly centred on the length of this line, but the way to check is to see that the top of the ear is level with the eyebrow, and that the lobe is level with the tip of the nose. Generally speaking, in the case of most younger people, the lips project in front of the line between the forehead and the chin. For the elderly, especially those who have lost their teeth, this may not always be so.

Details of the features

You will always need to look at your sitter's features in detail to see their particular characteristics. Before you start drawing, check how they relate to each other in distance and angle.

Eyes

Looking at the eyes of your model, viewed from the front, the corners may be aligned exactly horizontally; or the inner corners may be lower than the outer ones, which will make them look tilted up; or the outer corners may be lower than the inner ones, which will make them look tilted down.

Mouths

Mouths may be straight along the central horizontal; or curved upwards at the outer corners; or curved downwards at the outer corners.

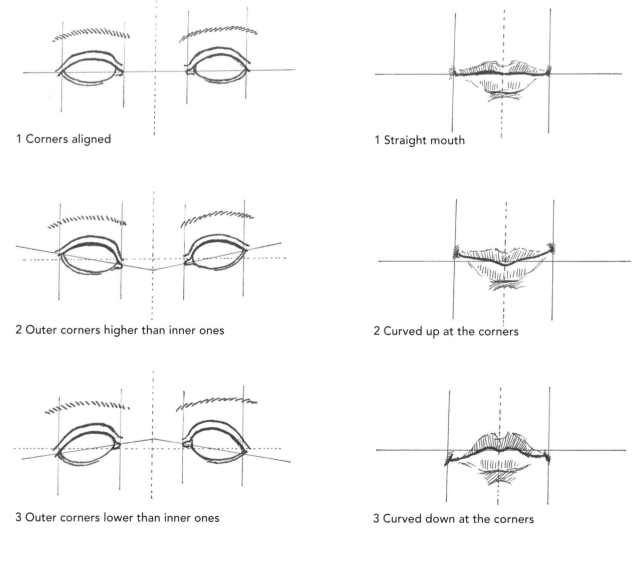

1 Corners aligned

1 Straight mouth

2 Outer corners higher than inner ones

2 Curved up at the corners

3 Outer corners lower than inner ones

3 Curved down at the corners

Ears

Ears are unique to the individual but the basic shape is very similar to the first diagram here. The other drawings show some possible variations.

Noses

Noses vary in shape but all project a certain distance from the surface of the face. Here are six types of nose for a start, and no doubt you will be able to find more.

The first three are masculine, and this one is a relatively straight nose.

The next is a more aquiline shape, with the bony structure giving the bridge a distinct curve.

The next is the classic boxer's broken nose, with the bridge crushed back into the face, leaving the tip protruding.

Now let's look at more feminine noses, which can have the same characteristics as the male ones, although rather finer in form. The first is the straight nose, and this can be really straight.

The aquiline version in the female form is not usually quite as dramatic as the masculine version, and the rest of the face is also usually softer and finer.

The retroussé or snub nose is often quite short and delicate in form.

Faces and expressions

The most interesting thing about a face is the way that it changes expression so easily and rapidly. We all watch these changes quite carefully in other people because they give the best clues to what our friends and relations are thinking about. Here are a few of the most obvious facial expressions, together with some suggestions for drawing them easily.

The smile

First, that most charming of all expressions, the smile: this is not quite so easy to draw as you might imagine, because it is quite a subtle image. If you make the mouth and eyes too exaggerated, the whole thing looks rather manic. So, it is important to show restraint in your drawing, marking the corners of the mouth very slightly curved, and the eyes only narrowed a little.

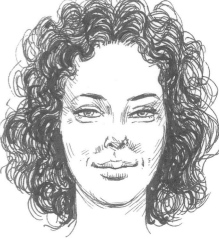

Surprise

The expression of surprise, however, is one where you can go over the top to good effect. Open the eyes so that the iris is not touching either the lower or the upper lids. Open the mouth into a fairly rounded shape and put some small lines above the eyebrows, which should be well arched. Some stress shadows around the jaw and nostrils will help portray the general air of astonishment too.

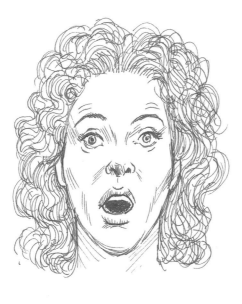

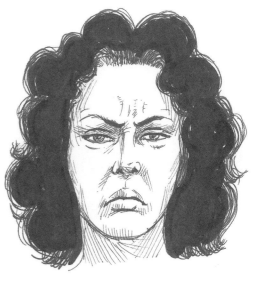

Anger

Anger is a good expression to depict because you can really let yourself go on the down-turning of the mouth and the knitting of the brows. The eyes may be narrowed, as in this picture, or opened wider to give a more ferocious aspect. Frown lines in the middle of the brow, and lines from the corner of the nostrils and under the mouth, all help to make the face look suitably lowering.

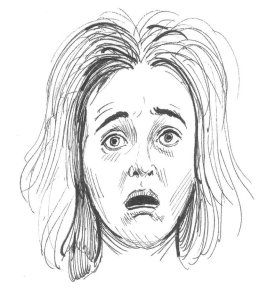

Fear

Fear is a difficult one because it is all too easy to make it look ludicrous. Make sure that the whites of the eyes show all around the irises. The eyes are wide open and the eyebrows are arched as high as they will go, with lines on the forehead above them. Shadows under the eyes also help. The mouth is open but turned down, with lines around it and the nostrils.

Laughter

Laughter can also look a bit mad, if you overdo it, but the key feature is the widely stretched mouth with an upturn at the corners. The eyes should be almost closed and there should be creases around the mouth and nostrils. Make sure that the cheeks are rounded and perhaps add dimples either side of the mouth.

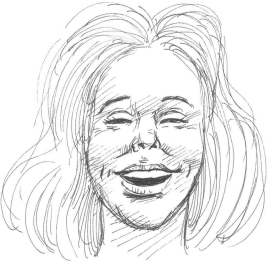

Satisfaction

Satisfaction is a rather more subtle expression, and closed eyes that still look relaxed are a good sign. The mouth should be very gently smiling – nothing too exaggerated. The head held to one side completes the picture.

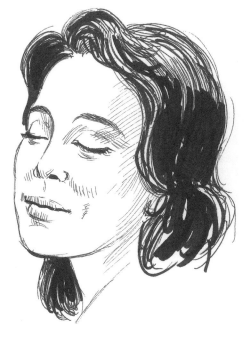

Mapping out the portrait

Starting on a portrait is always a bit tricky, but there are time-honoured methods of approach that should help you.

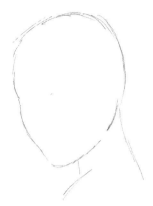

First, treat the head like any other object and make a rough sketch of the overall shape. This is not as easy as it sounds because the hair often hides the outline and so you may have to do a little bit of guesswork to get as close to the basic shape as you can.

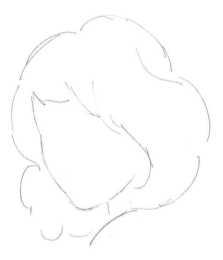

When you have done that, block in the hair area quite simply – without trying to make it look like hair – and note how much of the overall shape it occupies.

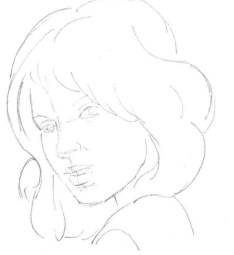

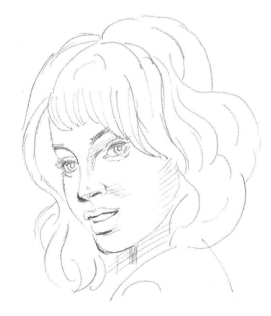

Now comes the most critical part of the drawing, the features. These must be placed at the correct levels on the face, in a very simple form. Check by measuring if you are in any doubt, but remember that normally the eyes are halfway between the top of the head and the point of the chin, and make sure that they are far enough apart. Also, check the size of the nose and its relationship with the mouth. In this example, the face is seen three-quarters on, and this means that the space occupied by the far side of the face measures much less than the near side.

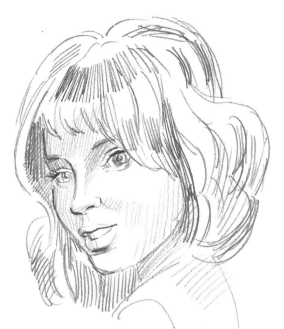

Having sketched the features in the right place – and made them basically the right shape – now draw them in greater detail.

Mark the main areas of shadow; keep shading light to start with and add more intensity when you are satisfied that all is correct. Finish off by refining both the shapes and the tonal areas.

An alternative method

Using this method, you start with a line down the centre of the face, drawn from the top of the head to the chin and neck. Mark this line at eye level (halfway down the whole length), then a line for the mouth, the tip of the nose, and the hairline. Check these thoroughly before moving on.

Now carefully draw in the eyes, the nose, the mouth, the chin, and the front of the hair.

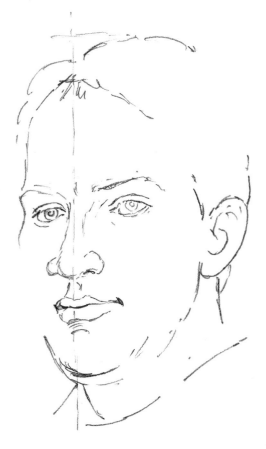

Ascertain the position of the nearer ear in relation to the eyes and nose. Next, draw these in clearly so that you can see if the face looks right. If not, alter anything that doesn't appear like your sitter's face.

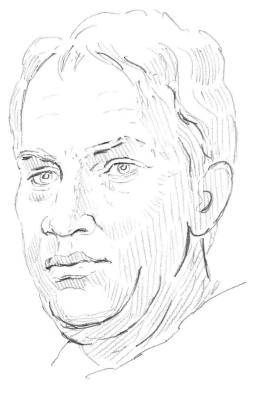

Now you can put in all the rest of the head outline and then the main areas of shading. At this stage, shade lightly, in case it needs to be changed.

After erasing the initial guideline, work in the more subtle tones and details of the face. You may need to increase the intensity of the tonal areas in some places.

This and the approach shown on pp.98–99 are two methods of achieving a good result.

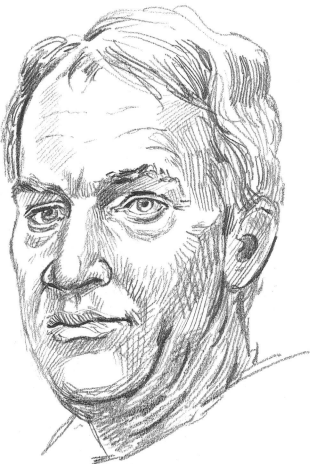

Portrait project: Step one

Your first concern when you set out to draw a portrait is how to
pose your subject. There are many possibilities and you must decide
how much you wish to draw of the subject, apart from the face.
You might choose the whole figure, or go for half or three-quarters;
your subject may well have ideas on how he or she wants to be
drawn too.

In this session, I decided to draw
my daughter and so I sketched
out various positions that she
might sit in.

In a chair . . .

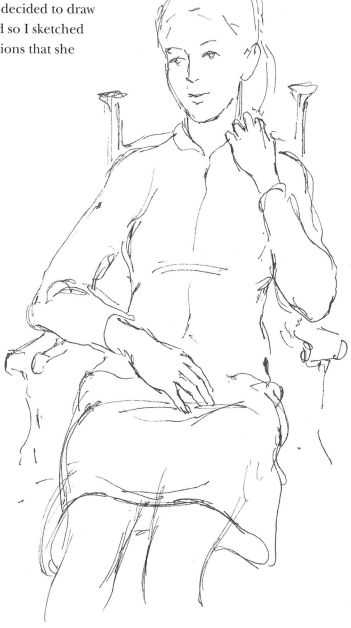

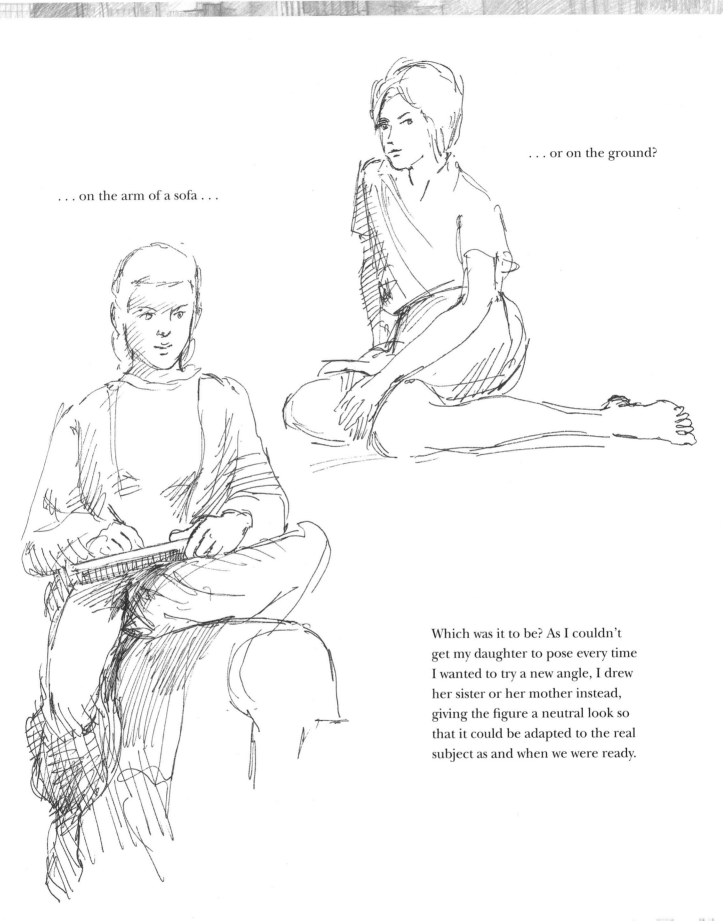

. . . or on the ground?

. . . on the arm of a sofa . . .

Which was it to be? As I couldn't
get my daughter to pose every time
I wanted to try a new angle, I drew
her sister or her mother instead,
giving the figure a neutral look so
that it could be adapted to the real
subject as and when we were ready.

Portrait project: Step two

To make sure that you are familiar enough with the facial features of your subject, you need to produce several sketches of the face from slightly different angles, so things are easier when you come to do the finished drawing.

Of course, I had been familiar with my own daughter's face over the years, and was able to call on several drawings that I had done before, which I studied carefully for the salient features.

There was this profile, which is quite easy to draw as long as you get the proportions right. The hair tends to dominate a side view.

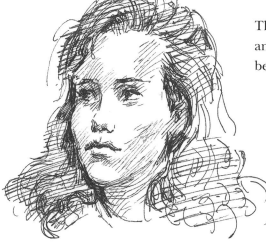

This three-quarter view is the kind of angle that people like in a portrait, because the face is more recognizable.

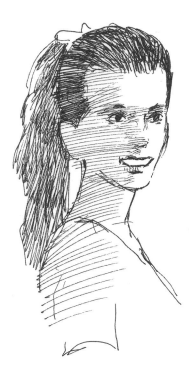

This drawing, glimpsed from a distance when she was smiling, is useful but it doesn't give much detail to the face. This is often the sort of result that you get from a quick snapshot.

This view of her was drawn while she was busy reading and almost unaware of me. This could work quite well, but her face is slightly obscured.

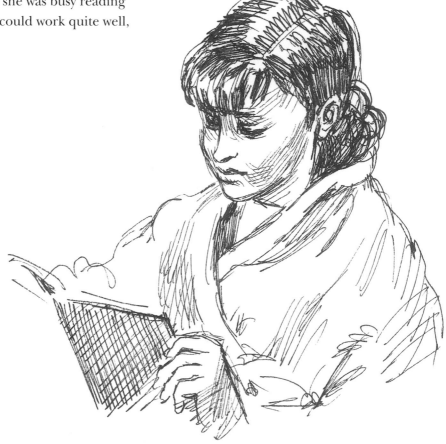

And finally, here is a straightforward drawing of an almost full-face view.

Repeated attempts help to produce a better piece of work in the end, so don't hurry to start your final drawing until you've done a reasonable amount of groundwork.

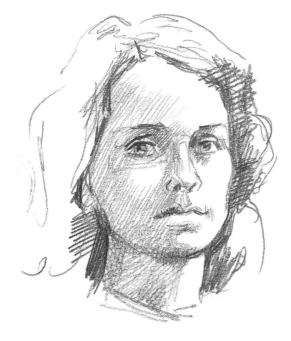

Portrait project: Step three

When I decided to do the final portrait, my daughter just sat down in a chair and told me I had only a short time to draw her as she had other things that she needed to do.

I let her arrange herself until she felt comfortable although, as you can see, she is perched on the edge of the chair, ready to go at a moment's notice. This is a mark of character that probably helps to give the drawing more verisimilitude.

The background was just the texture of a Venetian blind, so it was not too difficult to draw. I first sketched in the whole head and then the rest of the figure, to make sure that I had got all the proportions right. The facial proportions took three attempts before I was satisfied with the result.

I kept the shading simple and only allowed two grades of tone, a mid-tone and a dark one. I used the 2B pencil in a light, feathery way to put on large areas of tone evenly, and I emphasized certain areas where I thought the darkest shadows should be. This seemed to work all right and I finished off the portrait with a few areas of tone on the background, to help set the figure in the space.

Follow these steps when you come to try portraiture for yourself, and you should end up with a good drawing.

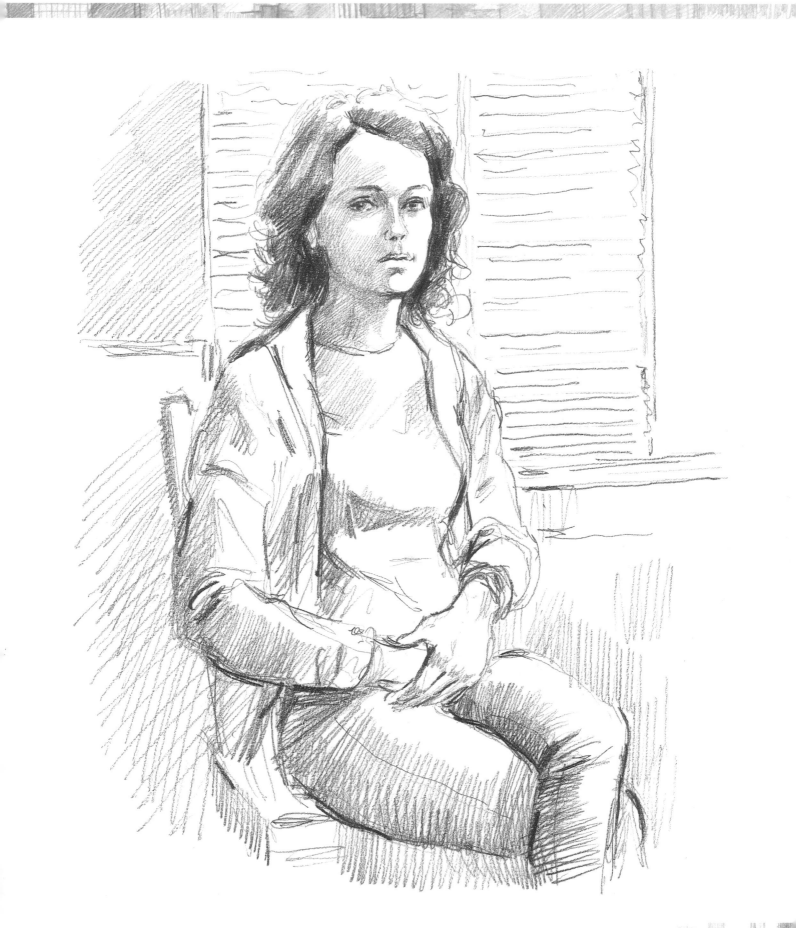

6 THE HUMAN FIGURE

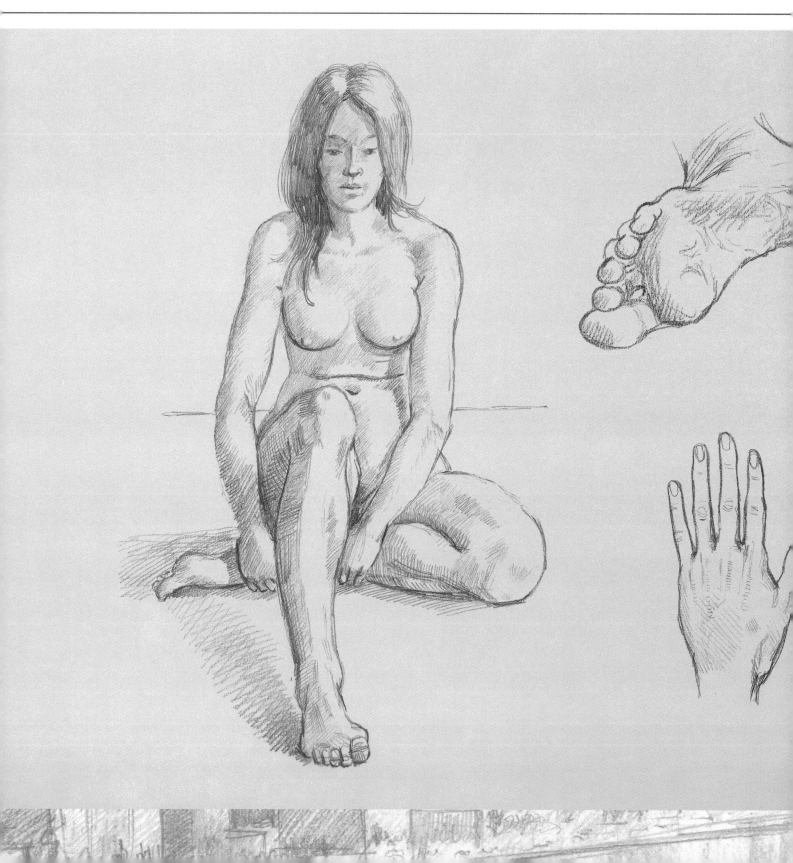

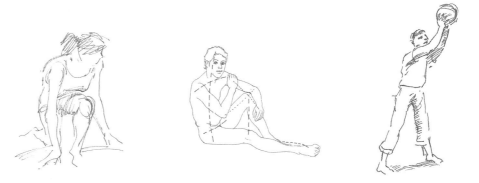

When you have gained confidence in your drawing skills it is time to have a go at drawing the human figure, which is both the hardest and the most satisfying subject for any artist. In this section you will start by studying the proportions of the human frame and learning how the shape of the body becomes altered by the movement of the limbs and torso. We shall also look in more detail at elements of the figure that many people find difficult – the hands and feet.

You will discover too how to arrange figures in a composition, remembering that the picture as a whole is more important than any single item that occupies it. This means that you must think carefully about how you place your figures within the picture, deciding which ones should be more dominant and which should be less so.

Looking at the ways in which different artists have drawn the human form, you will see how varied your own approach might be to rendering figures in different poses. Not all artists are realists with regard to drawing the human figure; they can and do interpret it in many interesting and remarkable styles. Movement can also be shown in various ways to bring life and drama to a composition.

All in all, there are many enjoyable aspects to drawing the human figure and for many artists this is their main goal. Even if it is not your own major interest, you will find that the ability to draw people as well as objects and landscapes will increase your range of subject matter enormously.

Basic proportions

You will see that I have divided up this diagram of the human figure into seven and a half units; these are not precisely everyone's proportions but represent an average.

It is generally accepted that the length of the head from top to chin will fit more or less seven and a half times into the length of the whole body. The classic proportion was traditionally regarded as eight times, and although this was originally used to depict god-like figures or heroes and heroines, it is often the way modern photographers manipulate their fashion images to elongate the models and make them look more slender and graceful than they actually are. However, the proportion of seven and a half times is closer to reality.

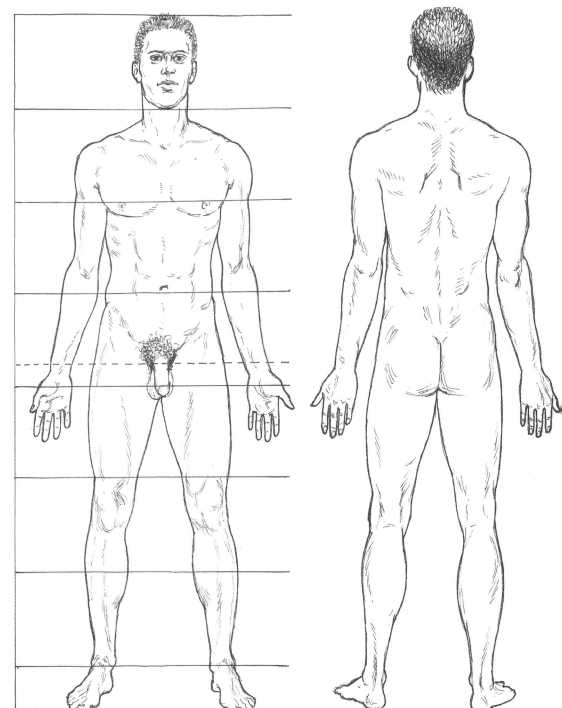

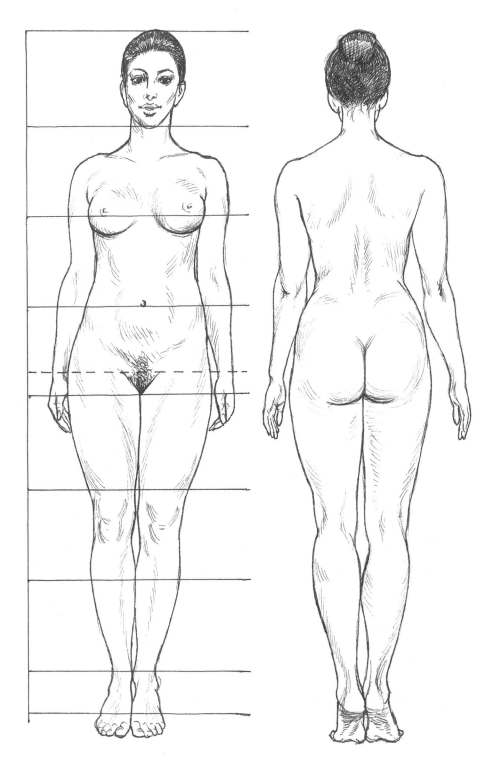

Note how both the figures shown here are the same height; in reality the female is probably shorter than the male but the proportion of head to height would remain the same. The halfway mark, shown by the dotted line, occurs at the base of the pubic bone. Surprisingly, the differences between the sexes are fairly minimal. The male figure is usually heavier in build, the skeleton often being significantly more solid than the female's; this is reflected in the fact that you will need to draw the female limbs, features and so on much more finely than you would for the male version. The female form also has a layer of subcutaneous fat that the male form lacks, so that she usually looks softer and rounder than her male counterpart. There are occasional exceptions to these rules, but these diagrams are a good starting point.

Analysing balance and pose

This group of figures demonstrates how to observe the human form and analyse how the torso and limbs are realigned and rebalanced in various poses.

Start off by visualizing a line from the top of the head to the point between the feet where the weight of the body is resting – this is its centre of gravity. Our system labels this line (from head to ground) as line A.

Next, take the lines across the body that denote the shoulders, hips, knees and feet. The way that these lines lend balance to the form tells you a lot about how to compose the figure. The system labels these as follows: the shoulders, line B; hips, line C; knees, line D; feet, line E.

Then, note the relationship between the elbows and the hands, although these are not always so easy to see. The system here is: the elbows, line F; hands, line G.

So now, as you glance down the length of the figure, your eye automatically notes the distribution of these points of balance. Concentrating your observations in this way, you will find it much easier to render the figure realistically.

The first figure is standing and the distribution of the various levels of balance can be seen quite clearly. The only one that is a bit difficult to relate to is line F, linking the two elbows.

The second figure is also standing, although the shoulders and hips are different from the first. Nevertheless, it is still fairly easy to see how the points relate to one another.

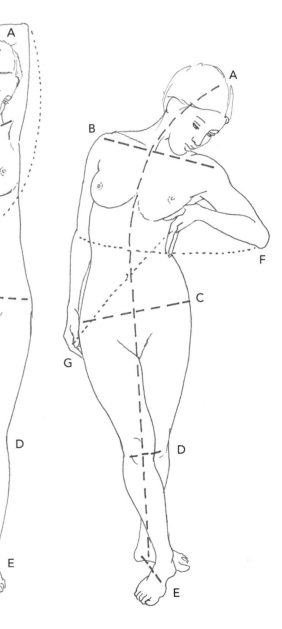

The third figure, still standing but sideways-on this time, makes some of the balancing points less significant. The hips, for example, are one behind the other so they don't register much. The hands are together, so that simplifies that aspect. But the remaining points are important to observe, in order to give the right kind of balance to the figure.

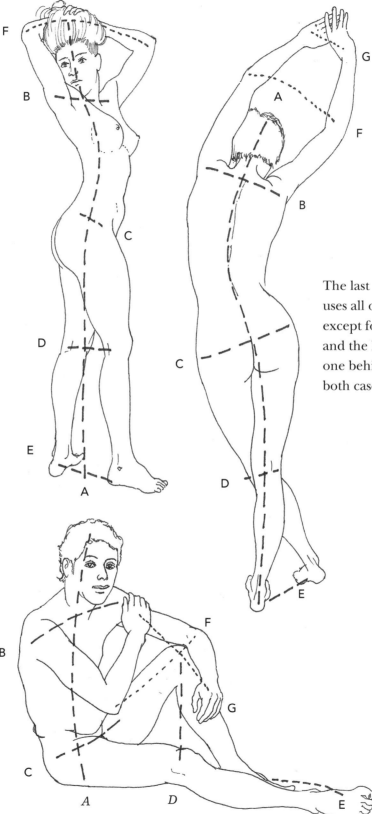

The last standing figure uses all of the points, except for the hands and the knees, which are one behind the other in both cases.

Now, we have a sitting figure in which the main line A is shortened to cover the upper part of the body only, because this is where the balancing line stops. However, the rest are obvious enough, although the lines connecting hands and elbows actually cut across each other in this pose.

Body details – hands and feet

I have often heard people saying, 'Oh, I can't draw hands and feet.'
Unfortunately, this is why their drawings leave a lot to be desired.
Yet, with the right approach, hands and feet are not any more
difficult to draw than the rest of the body and do make the figure so
much more convincing if they are put in properly.

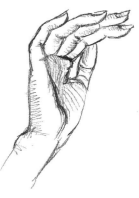

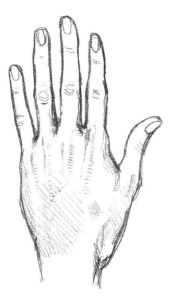

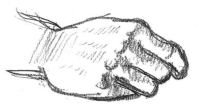

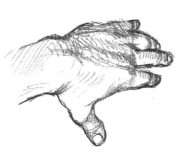

Hands

Look at hands in all their flexible
poses; you will need frequent practice
to be able to incorporate them into
your drawing with ease. Practise on
your own hands first, both directly and
in a mirror. Try sketching them from as
many angles as you can. Approach
them as though you were engaged in
depicting a whole figure, with the palm
as the torso and the fingers as the
limbs. This way, when you do come to
draw a full-length figure, you will not
dispatch the hands with some vague,
feathery marks.

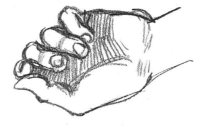

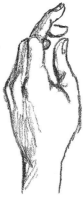

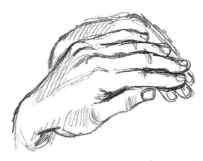

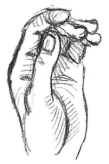

Feet

Feet are generally easier to draw, but because people rarely pay much attention to them, they tend to be quite unlike how they are imagined to be. The slightly wedge-shaped quality of the foot is refined by the way it joins the ankle and by the arrangement of the toes. I strongly recommend you to practise drawing feet from the front, in order to work out the shape of the toes. Frequent practice can rescue the extremities in your figure drawings from looking like unformed lumps of clay.

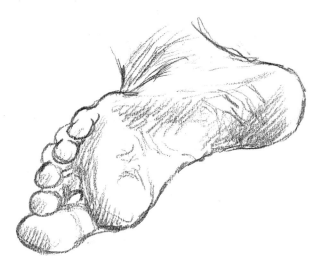

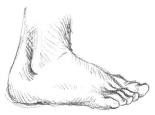

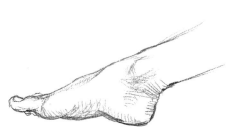

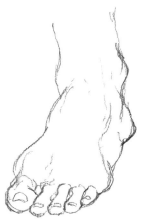

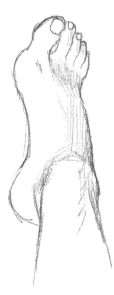

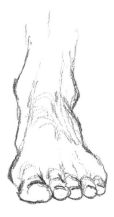

Blocking in the main form

When you come to draw a human figure from life, it's a good idea to simplify it at first. To start with, try blocking in the main shapes without any detail and then work on from that point.

Here is a female model, sitting with one leg tucked under the other. Studying the principal features, the outline of the figure can be clearly defined by the arms, legs, torso and head, put in without any detail. Before the next stage, check all the proportions and do not take the drawing any further until you are sure that the main shapes are in the correct relationship to one another.

When you are satisfied, move on to adding a bit more detail, such as the features of the face, the feet and hands. Then put in the shading, in a very basic form. Use one simple half-tone for all the shadow that you can see, whether dark or light. At this stage, this is all you need to indicate the solidity of the figure.

Then, once you are sure where all the shading should go, you can put in darker tones to round out the form more realistically. This is the time for any refinements to be added, where appropriate.

Drawing movement

Drawing a figure in motion is not easy, but at some time you should take the plunge and have a go at it. Instructing your model to keep repeating the same movement is one approach that works very well. You should try to capture each phase of the sequence and sketch it as well as you can. As the movement is repeated, you have the chance to take another look at phases that you have not been successful with first time around.

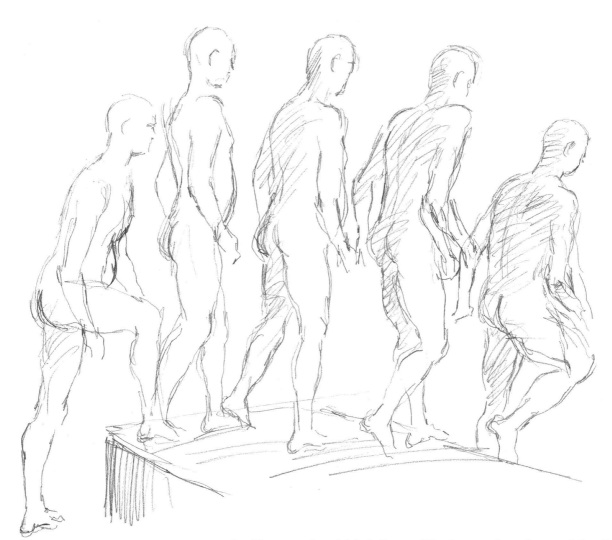

In this example, which is from a life-class session, the model walked across a dais over and over again, trying to keep the action the same each time. You could enlist the help of friends for this, if you were to choose some simple movement to begin with. Even if early attempts don't look too good, persevere with practising whenever you can and you will find that your 'fast drawing' will improve.

Catching the fleeting gesture

Once you have begun experimenting with action drawing, set yourself up in a place where you can view plenty of people walking about and see how many quick sketches you can get down. If that is not easy for you, ask a friend to move around more slowly and draw as many of their changes of position as you can.

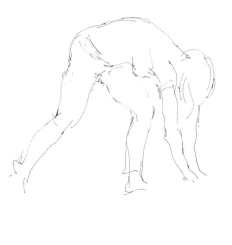

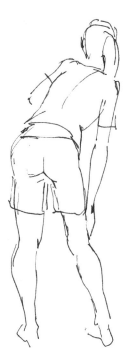

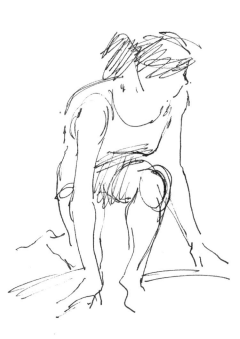

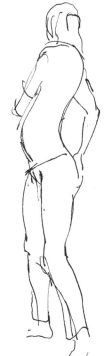

These drawings were all done extremely quickly, with the same model moving around and performing very simple, ordinary movements. Don't struggle to be very accurate – remember that the more you do this the easier it gets.

Approaches to composition

In these six compositions, I address the question of organizing a group of figures in various ways that you might find useful if you are attempting a picture where figures are the main feature. After a few attempts, you will probably want to try some ideas of your own.

The first example is set in a typical Italian café with wide open windows and doors that put everybody practically outside in the street. The two main figures sit under the café roof but also quite close to the people walking by. Outside can be seen a town with a campanile and other buildings, all in the sun. The two figures at the table take up most of the space, with a waiter to the right and a couple of passers-by visible between them. This is an informal composition that concentrates on the pair at the table.

In this interior scene the background is half dark and half light. The nearest figure is cropped by the lower edge. He is well lit and the curve of his body seems to hold the edge of the picture like a second frame. To the right, a woman faces him in a rather defensive posture that contrasts with his lounging pose, suggesting some kind of tension between them. The man in the centre background acts as a focal point to indicate the depth of the room and his position, above the knee of the foreground figure, seems to isolate the woman on the right. Note how important the picture depth is in making the composition work.

Next, I have drawn a beach scene with a suggestion of outdoor space and distance that the three figures help to define. Across the background lies a horizon line of sea and low cliffs. The nearest person has her back to us and appears ready to catch the ball, which has been thrown by the furthest one. However, halfway between these two is another player who has actually caught the ball. See how the differences in size of the three figures provide clues as to the space available on the otherwise empty beach.

This scene is of a park or public gardens and in the right foreground there is a seated figure, leaning against a tree as she reads a book. The vertical line of the tree trunk and the legs of the figure act like an additional frame to this picture. In the near left background, another tree acts like another part of the frame, underlined by the reclining figure on the grass, seen foreshortened. Two walking figures cross the middle ground of the picture. Once again, different elements of the composition contribute to the spatial quality of an open area.

This picture is definitely an interior, but also gives the sense of a larger than normal room. This is partly indicated by the spotlights criss-crossing the dark space above the dancers, and partly by the distance between the nearest couple and those further away on the dance-floor. The nearest dancers establish a stable focal point, while the jiving couple nearer the centre give the impression of movement within the space.

The last scene is another exterior composition, set this time in a garden with three figures performing typical outdoor activities. The space is enclosed, unlike the park and beach scenes, and typical garden vegetation seems to enfold the figures. The little boy in the foreground kicks a ball and the two adults get on with their gardening. They are all facing away from us, giving the impression that we are observing them without their knowledge. Either that, or they are just too busy to give us their attention.

Figure composition project: Step one

When I first decided to do this project, I thought that the most obvious and easiest subject matter for a figure composition was the weekly life-drawing group that I attend. I could draw people in situ and they might make a good arrangement. So, the subject matter here almost chose itself. You can be more adventurous, of course, but making your first attempts in surroundings that you are familiar with will be simpler and more effective.

Setting the scene

My chosen venue was the studio in which my class normally takes place and which I can get into any time I need to. I carefully drew up a view of the studio from the position that I thought would be most appropriate for my picture. I placed the easels around the dais, so that when the students came in they would probably fit into the pattern I had set up.

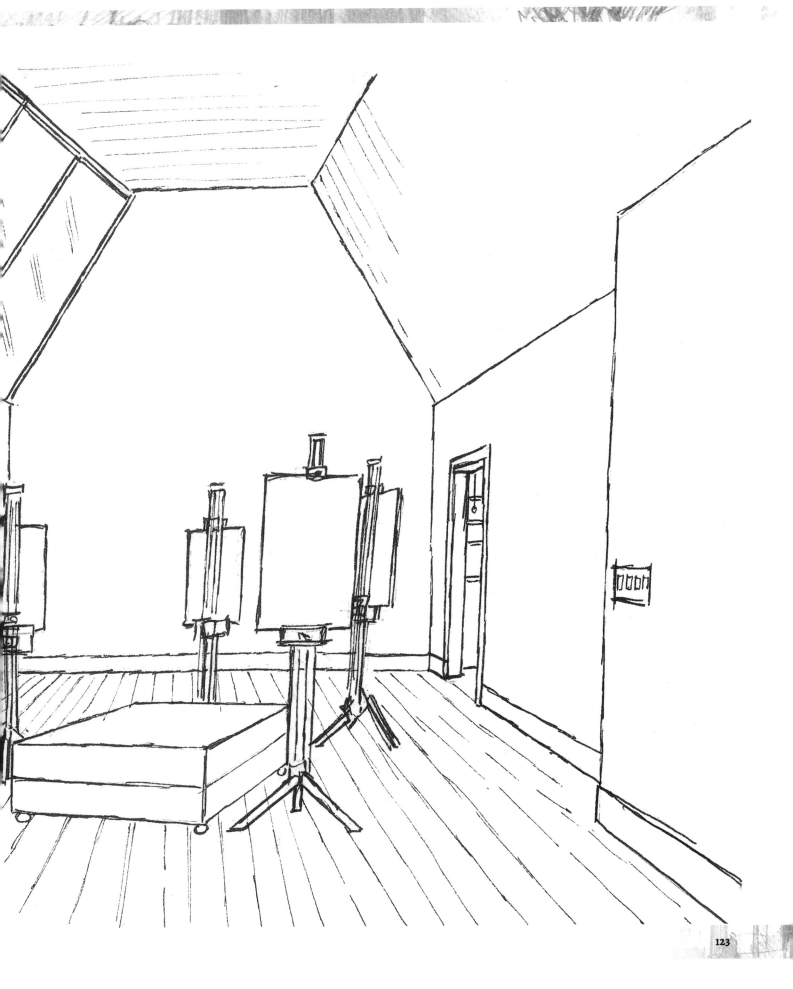

Figure composition project: Step two

The next thing was to wait until the art students were all busy drawing and quickly sketch them in as they worked.

First figure

The first figure was a man who worked away vigorously and took not the slightest notice of anyone who might be drawing him.

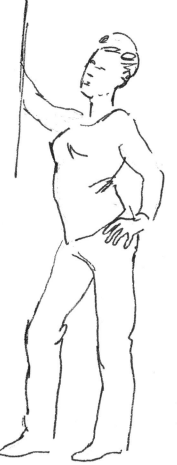

Second figure

Then I got the back view of a girl who was working quite quickly. I put in two different positions of her drawing arm, in case I preferred one to the other.

Third figure

Next, I drew another woman on the far side of the studio, who was working slowly and deliberately, with her hand on her hip and her head tilted to one side.

Fourth and fifth figures

Then I chose two more students on the far side of the room and tried to capture their steady stare towards the model as they drew. I had to decide whether to draw them when their gaze was on the model or on their drawing and decided the former was more interesting.

The model, centre of the scene

Finally, I had to put in the reason that these people were all there, which is the model who poses for them. This was easier, because the model held still, whereas the students moved about quite a bit.

Figure composition project: Step three

Having made decent sketches of all the players in the scene, I had to put them together to make a complete figure composition. The only real problem was to get the figures in the right proportions to one another, so they looked as if they were all inhabiting the same space. I also needed to make sense of the light falling both on the figures and within the room setting, but this wasn't such a problem because I had drawn everyone from the same vantage point and the light was therefore the same for each one. If you draw people initially in different lights and you want to make a group composition, you will have to balance them out in the final picture.

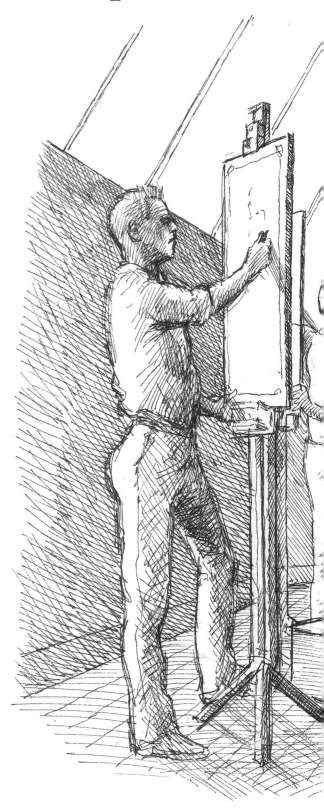

I used pen and ink to do the final drawing, partly because I had drawn the original figures in ink and partly because it forced me to be more economical with my shadows. The hundreds of small strokes you have to make with a pen mean that you don't put in any more shading than is absolutely necessary.

Now have a go at this yourself and have fun with it. Do not feel too despondent if your first attempt is not successful, for it is one of the most demanding types of composition that you can attempt.

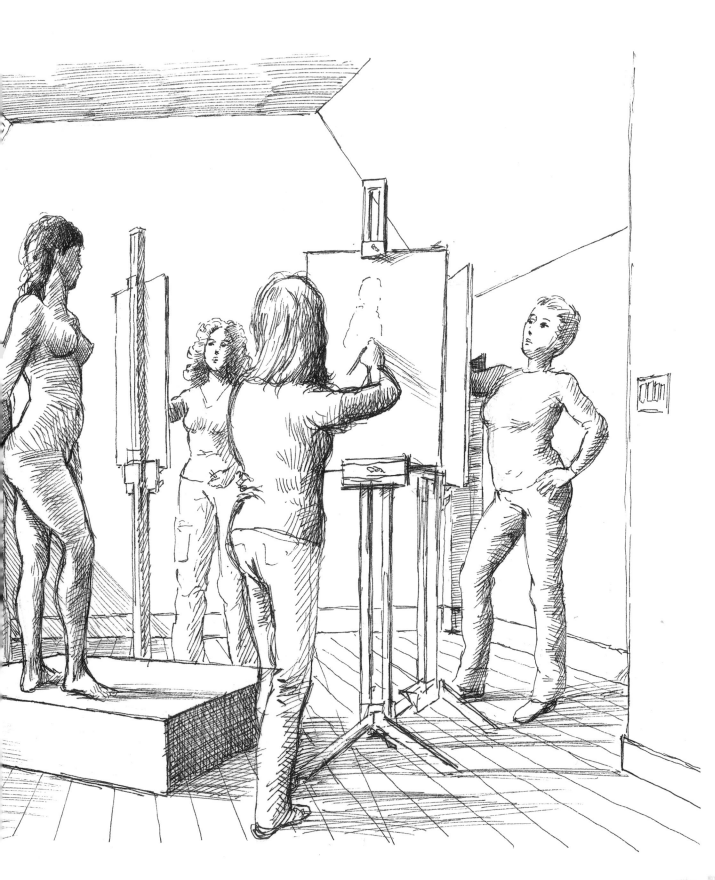

Index